Masterpieces of

Rembrandt

(1907)

ISBN-13 : 978-1512320244
ISBN-10 : 1512320242

Copyright©2012-2014 Iacob Adrian
All Rights Reserved.

Notice

This documentary study use historic, archived documents.

Because of this, some pages may look blurry or low quality.

Still are included in this book because they have

high value from critical, documentary, historical,

informative and journalistic point of view .

Dtp and visual art

Iacob Adrian

THE
MASTERPIECES
OF
REMBRANDT

Sixty reproductions of photographs from the original paintings by F. Hanfstaengl, affording examples of the different characteristics of the Artist's work

Author statement

This is a series of art books .

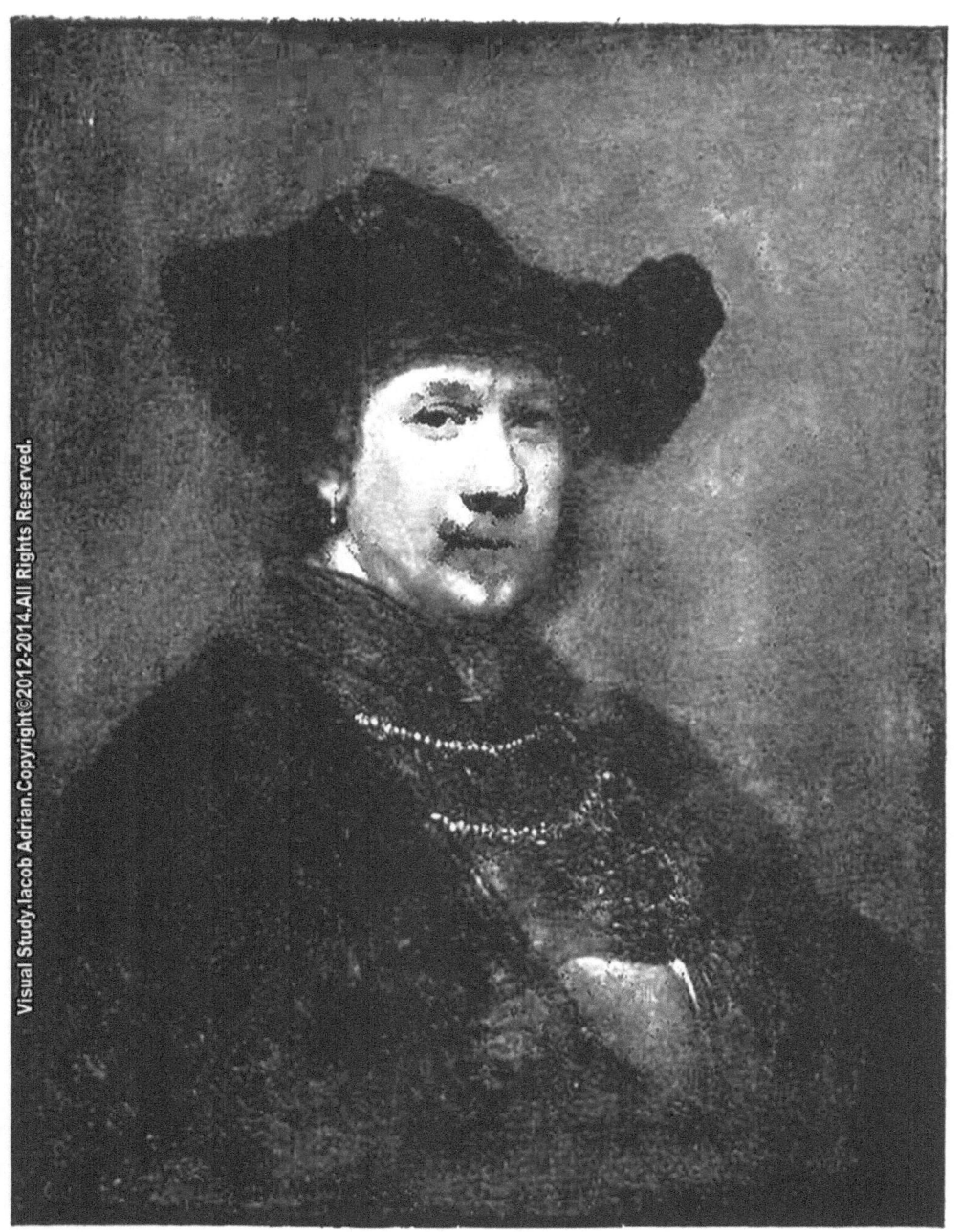

PORTRAIT OF HIMSELF PORTRAIT DE L'ARTISTE
(*Buckingham Palace, London*) (*Palais Buckingham, Londres*)
SELBSTBILDNIS
(*London, Buckinghampalast*)
F. Hanfstaengl, Photo.

This little Book conveys the greetings of

..

to

..

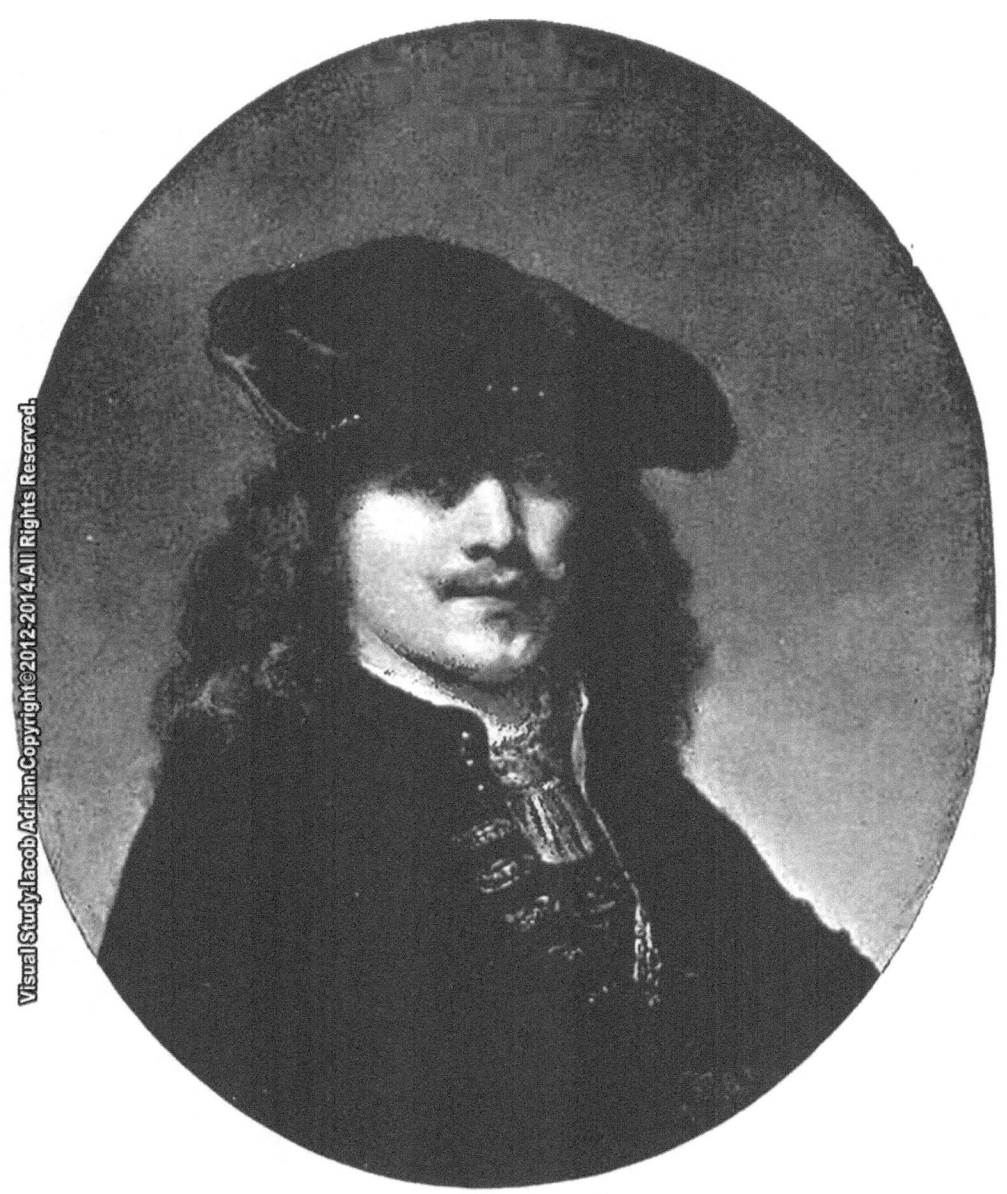

PORTRAIT OF HIMSELF PORTRAIT DE L'ARTISTE
(*Corporation Gallery, Glasgow*) (*Galerie municipale, Glasgow*)
SELBSTBILDNIS
(*Glasgow, Städt. Galerie*)
F. Hanfstaengl, Photo.

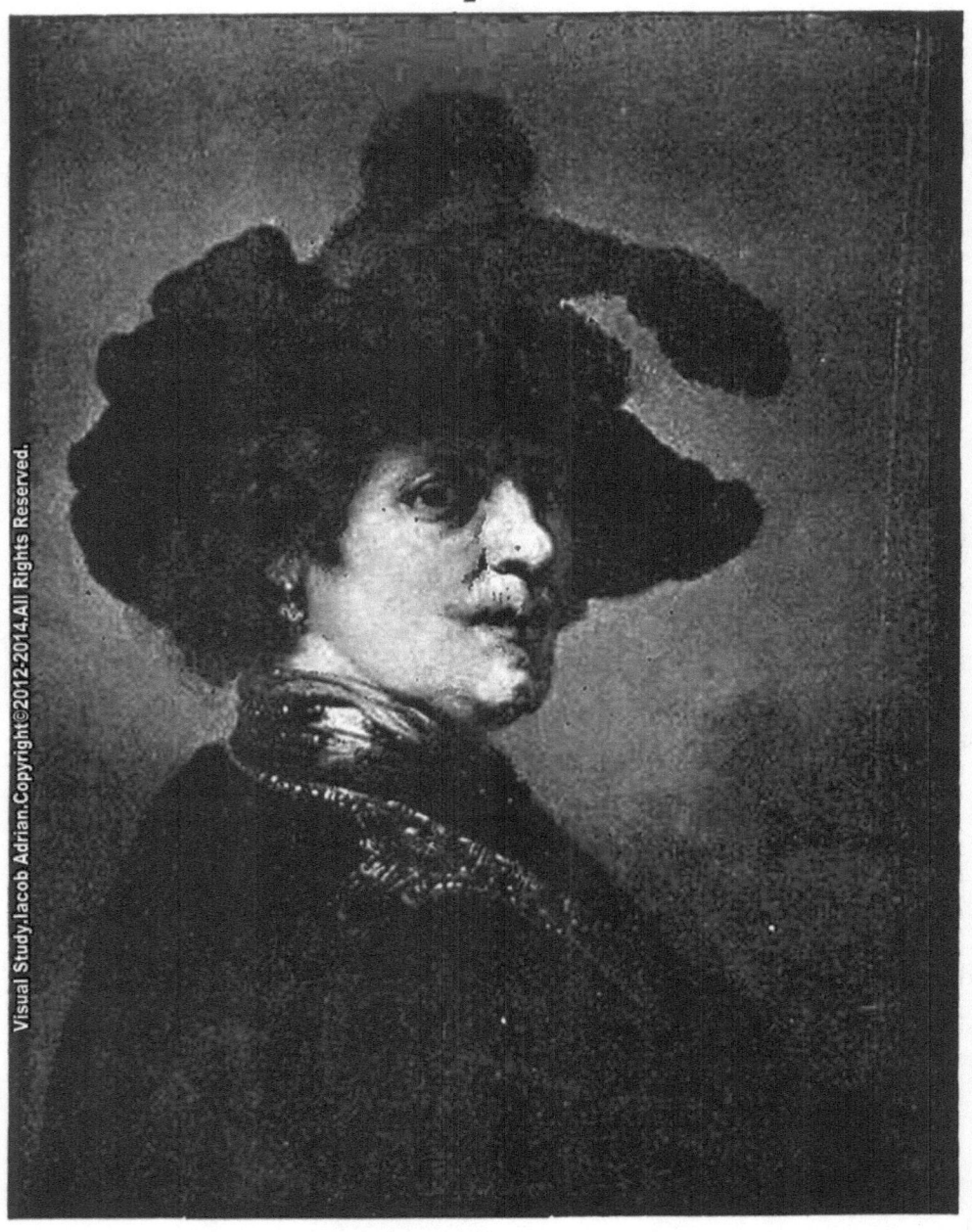

PORTRAIT OF HIMSELF
AS AN OFFICER
(*Royal Gallery, The Hague*)

PORTRAIT DE L'ARTISTE
EN OFFICIER
(*Musée royal, La Haye*)

SELBSTBILDNIS ALS OFFIZIER
(*Haag, Kgl. Galerie*)
F. Hanfstaengl, Photo.

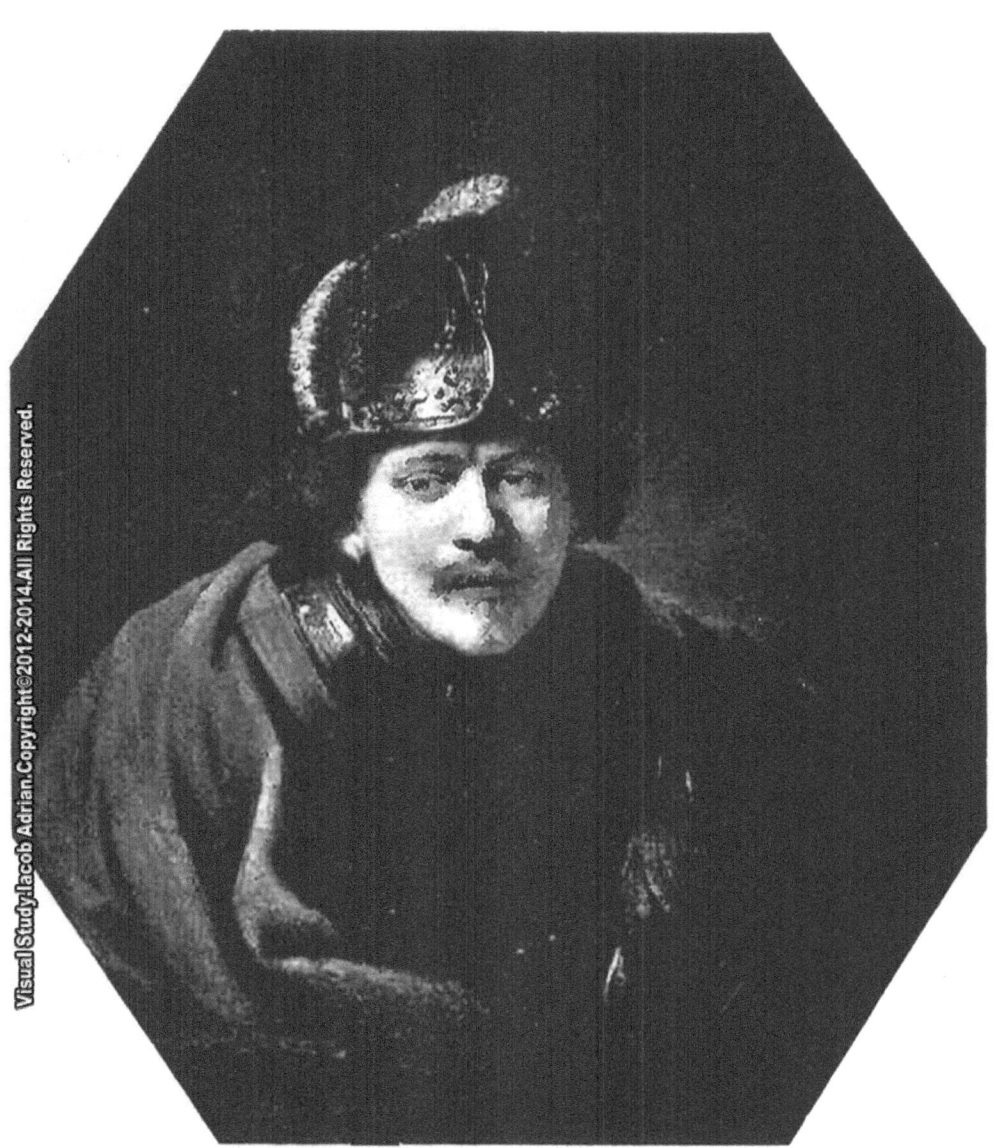

PORTRAIT OF HIMSELF
WITH A CASQUE
(*Royal Gallery, Cassel*)

PORTRAIT DE L'ARTISTE
AVEC CASQUE
(*Galerie royale, Cassel*)

SELBSTBILDNIS MIT EINER STURMHAUBE
(*Cassel, Kgl. Galerie*)
F. Hanfstaengl, Photo.

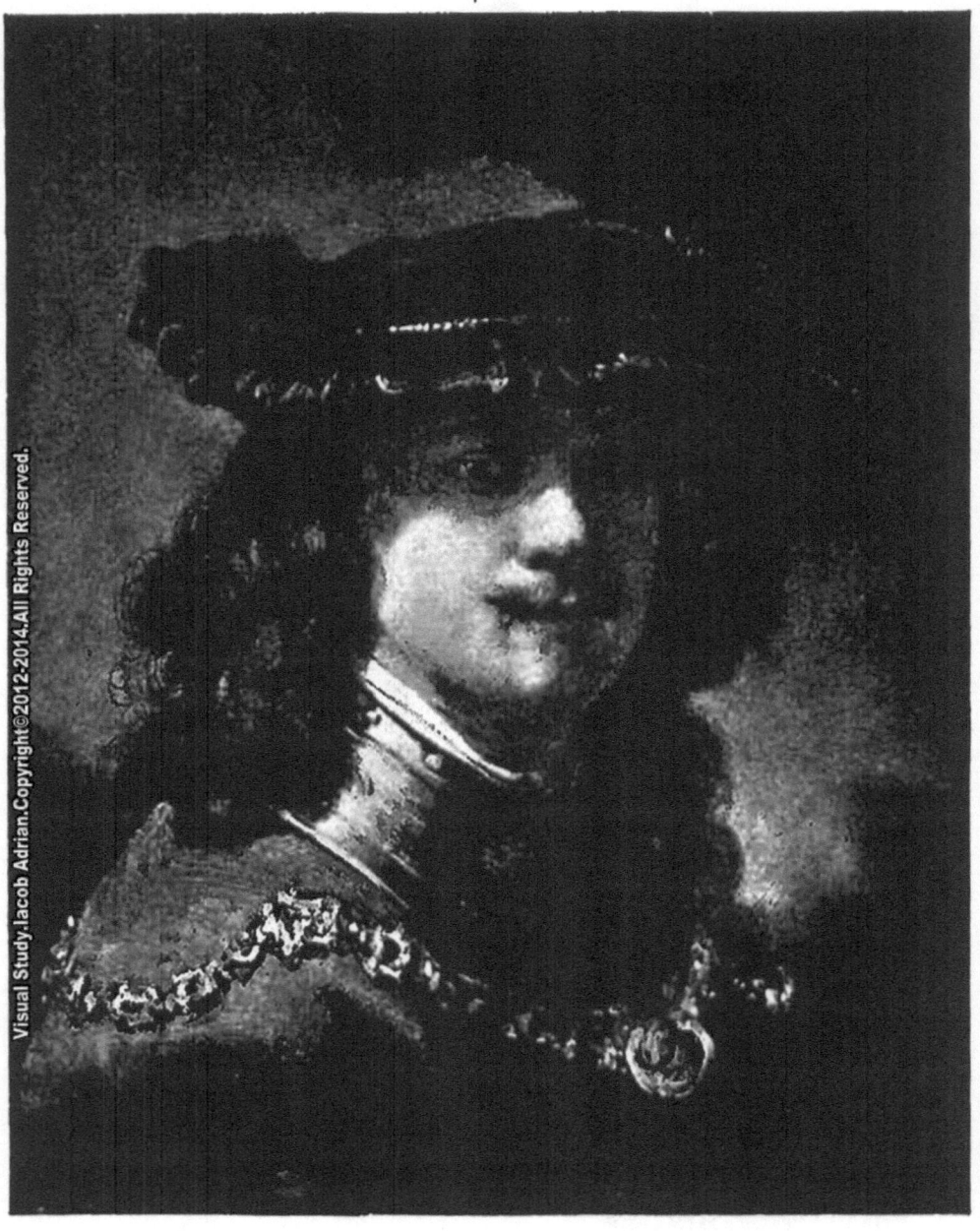

PORTRAIT OF HIMSELF
WITH A GORGET
(*Royal Gallery, Berlin*)

PORTRAIT DE L'ARTISTE
AVEC GORGERIN
(*Musée royal, Berlin*)

SELBSTBILDNIS MIT EINEM EISERNEN HALSKRAGEN
(*Berlin, Kgl. Galerie*)
F. Hanfstaengl, Photo.

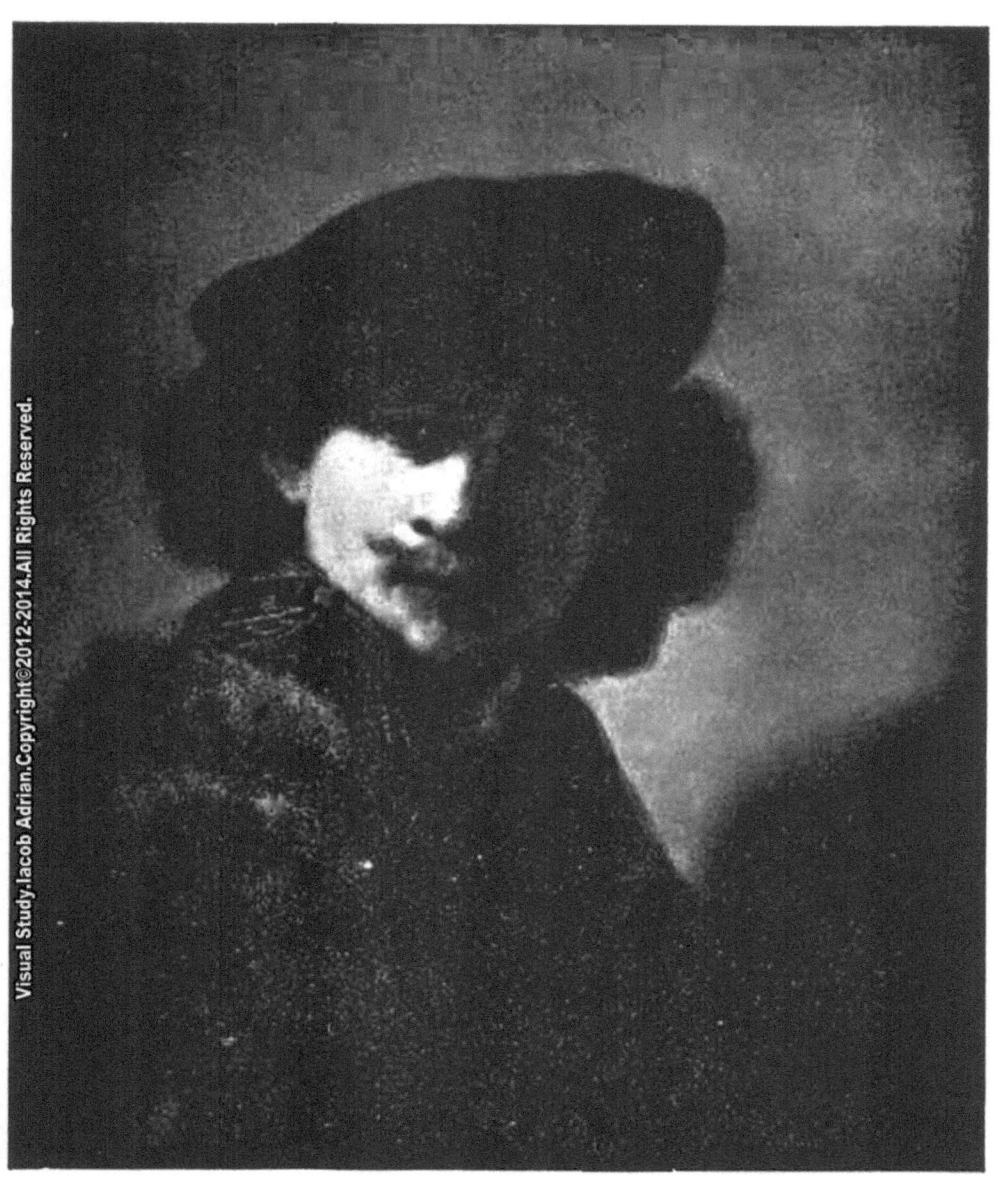

PORTRAIT OF HIMSELF
(*Royal Gallery, Berlin*)

PORTRAIT DE L'ARTISTE
(*Musée royal, Berlin*)

SELBSTBILDNIS
(*Berlin, Kgl. Galerie*)
F. Hanfstaengl, Photo.

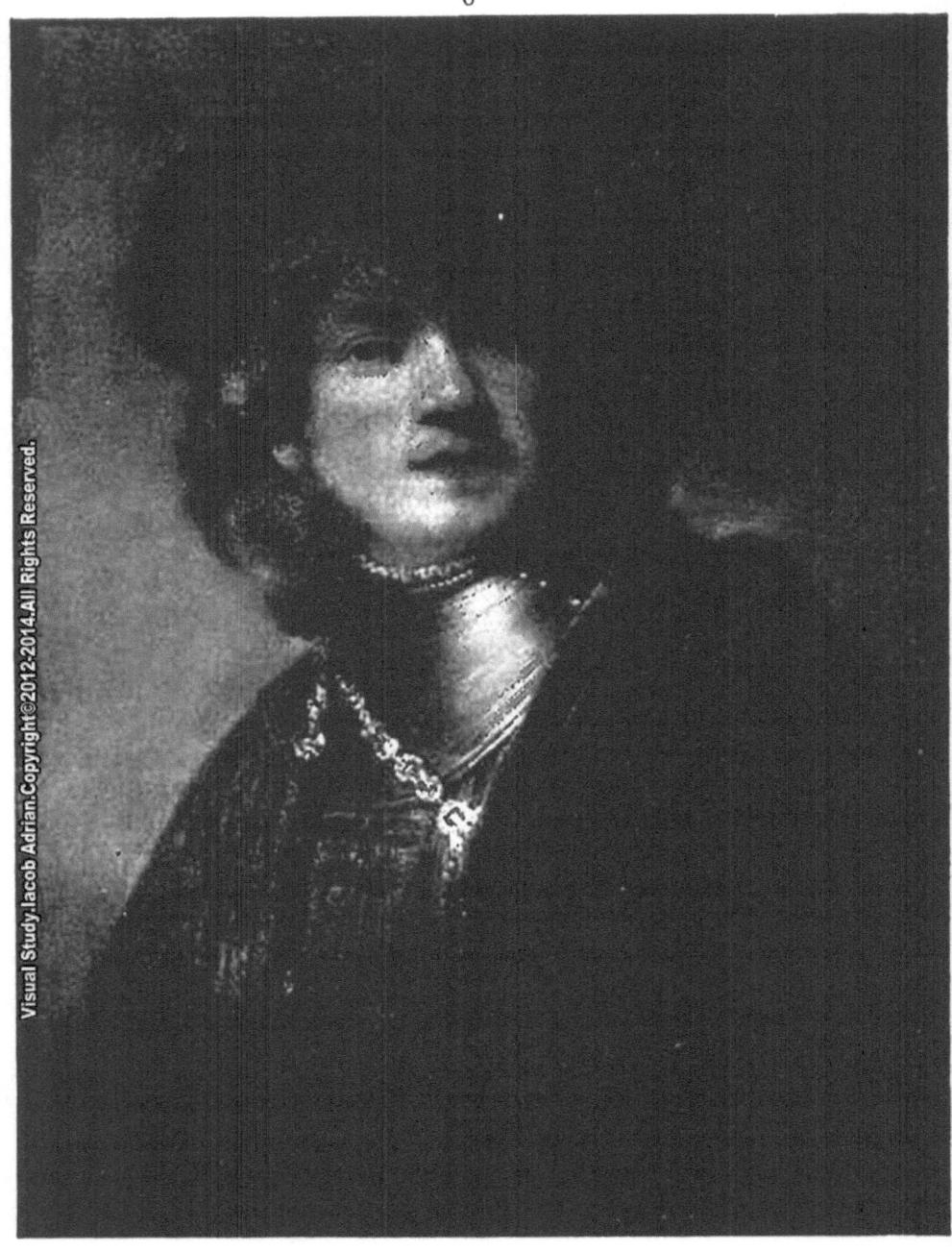

PORTRAIT OF HIMSELF
(*Pitti, Florence*)

PORTRAIT DE L'ARTISTE
(*Galerie Pitti, Florence*)

SELBSTBILDNIS
(*Florenz, Galerie Pitti*)
F. Hanfstaengl, Photo.

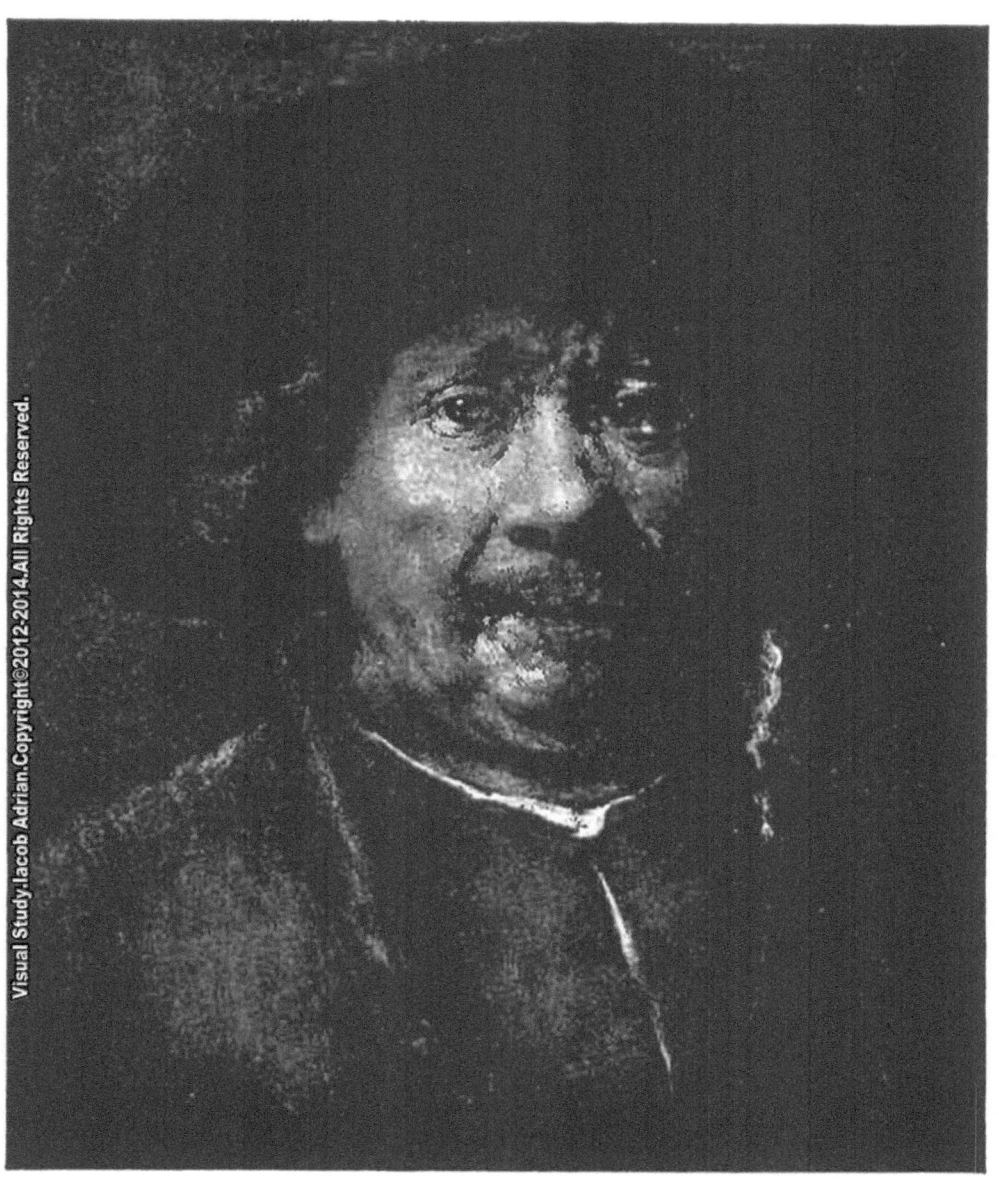

PORTRAIT OF HIMSELF PORTRAIT DE L'ARTISTE
(*Imperial Gallery, Vienna*) (*Galerie impériale, Vienne*)
SELBSTBILDNIS
(*Wien, Kaiserl. Galerie*)
F. Hanfstaengl, Photo.

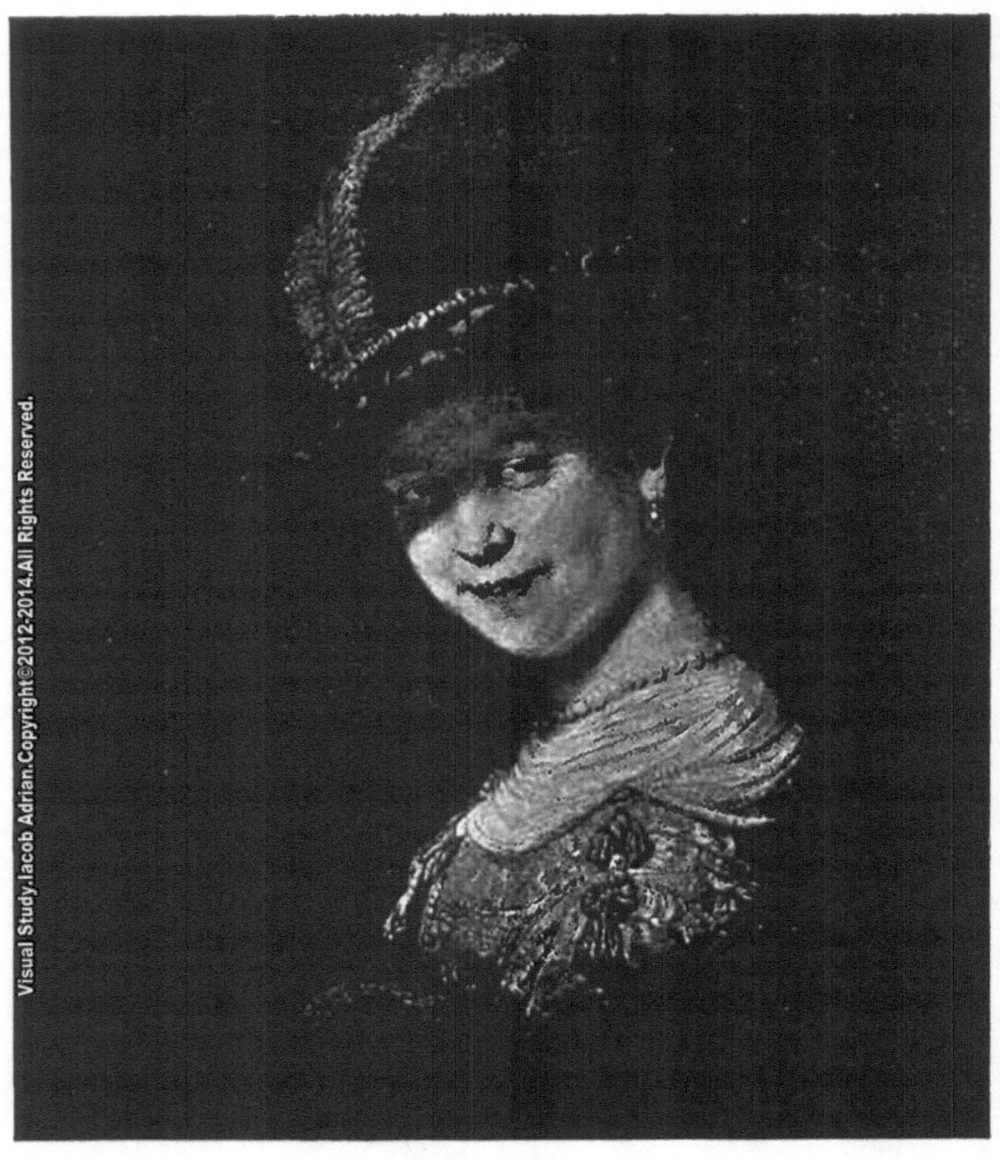

REMBRANDT'S WIFE SASKIA
AS A YOUNG GIRL
(Royal Gallery, Dresden)

SASKIA, PREMIÈRE FEMME DE
L'ARTISTE
(Galerie royale, Dresde)

REMBRANDTS GATTIN SASKIA ALS JUNGES MÄDCHEN
(Dresden, Kgl. Galerie)
F. Hanfstaengl, Photo.

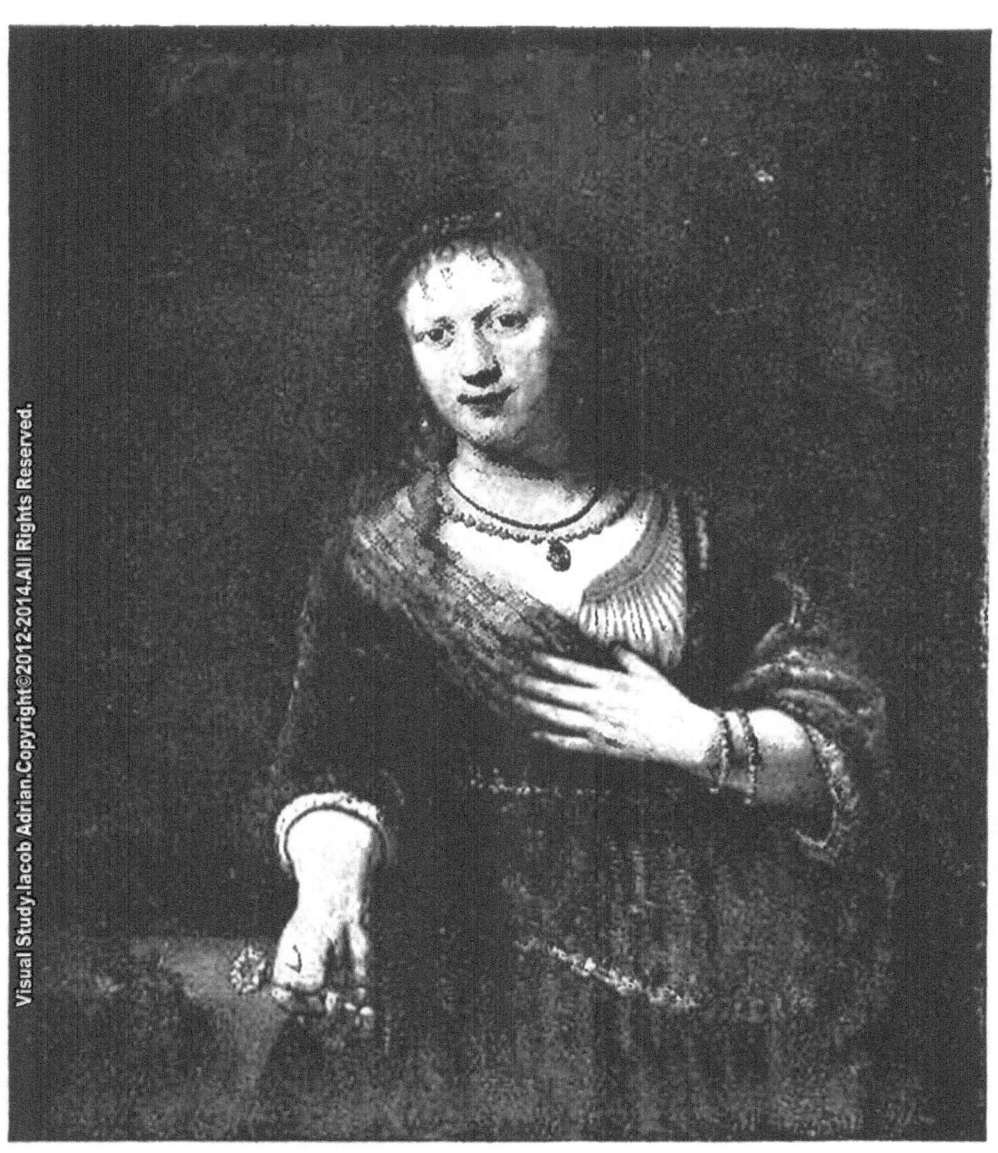

SASKIA WITH A RED
CARNATION
(Royal Gallery, Dresden)

SASKIA, TENANT UN
ŒILLET ROUGE
(Galerie royale, Dresde)

SASKIA MIT EINER ROTEN NELKE
(Dresden, Kgl. Galerie)
F. Hanfstaengl, Photo.

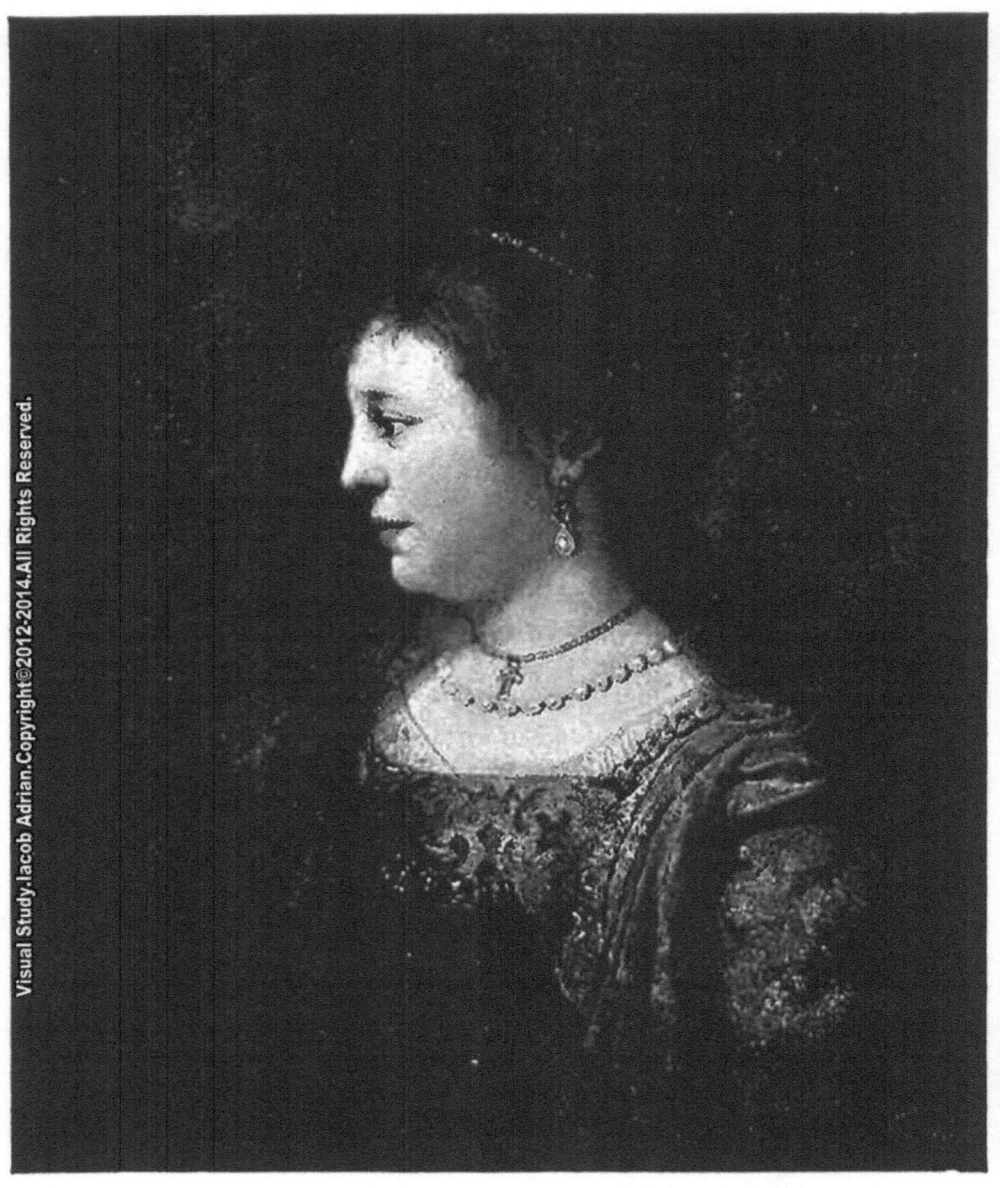

SASKIA
(Mrs. Joseph's Collection, London) (Collection de Mme. Joseph, Londres)
SASKIA
(London, Sammlung der Frau Joseph)
F. Hanfstaengl, Photo.

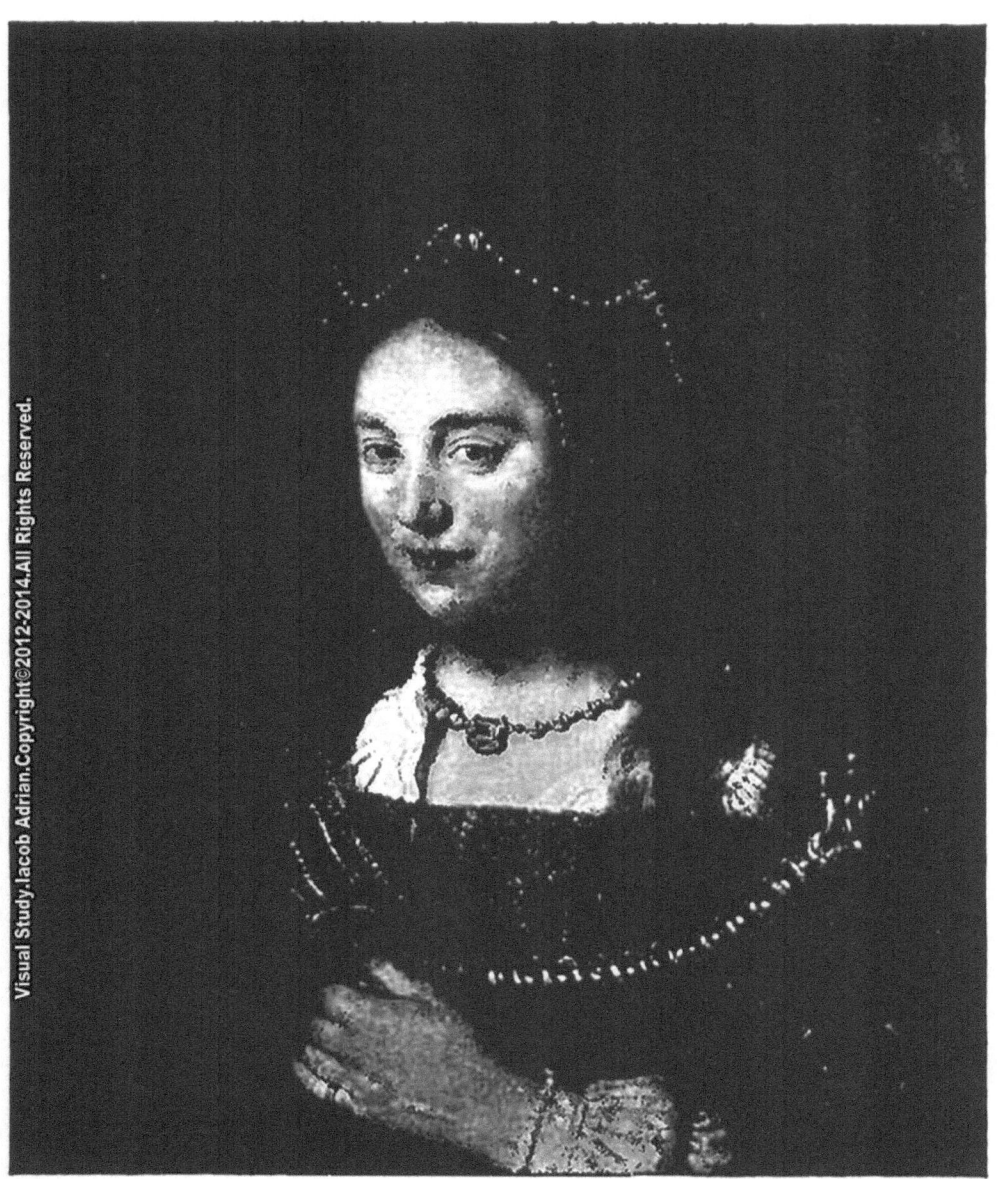

SASKIA
(*Royal Gallery, Berlin*)

SASKIA
(*Musée royal, Berlin*)

SASKIA
(*Berlin, Kgl. Galerie*)
F. Hanfstaengl, Photo.

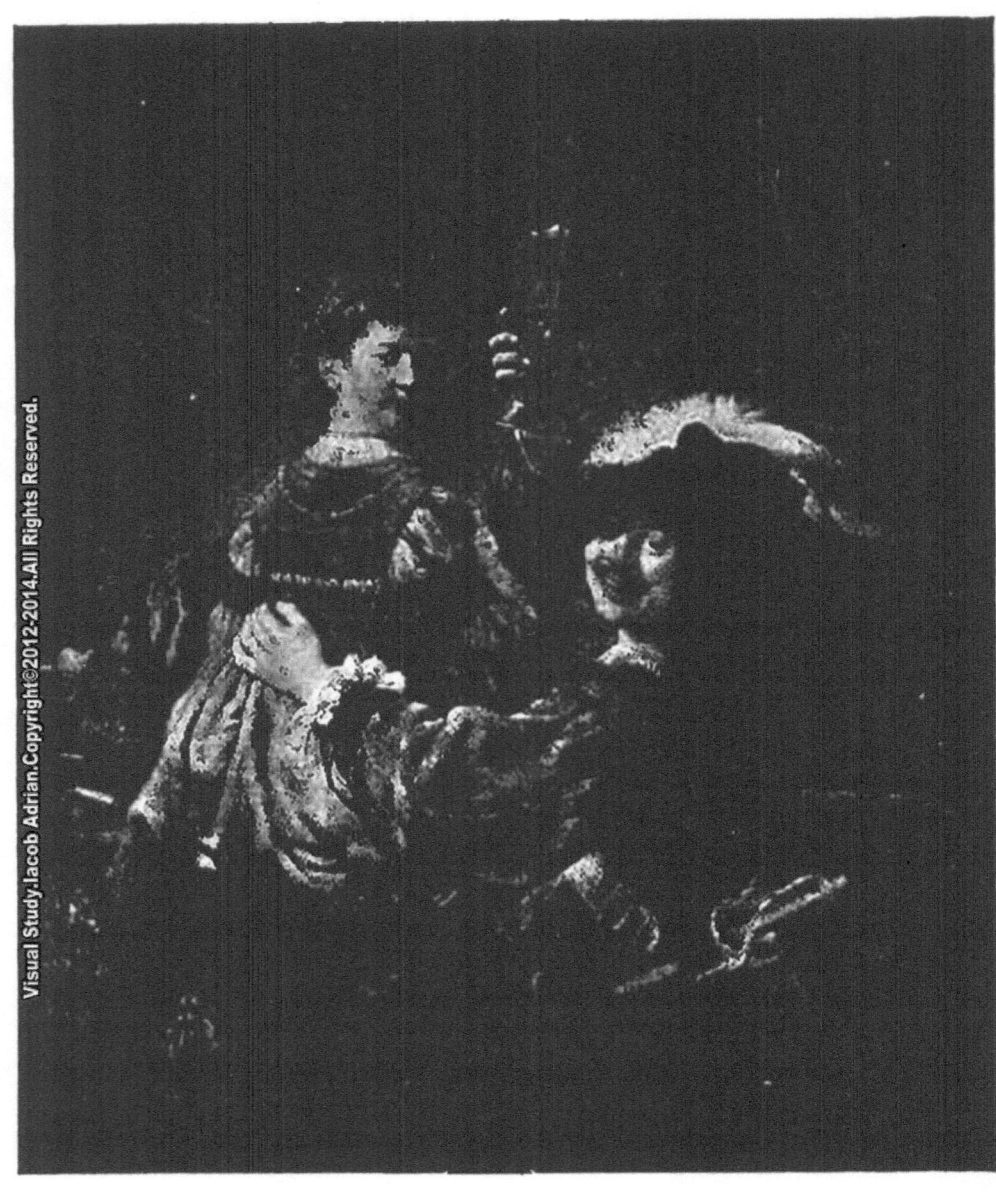

REMBRANDT AND SASKIA
(*Royal Gallery, Dresden*)

REMBRANDT ET SASKIA
(*Galerie royale, Dresde*)

REMBRANDT UND SASKIA
(*Dresden, Kgl. Galerie*)
F. Hanfstaengl, Photo.

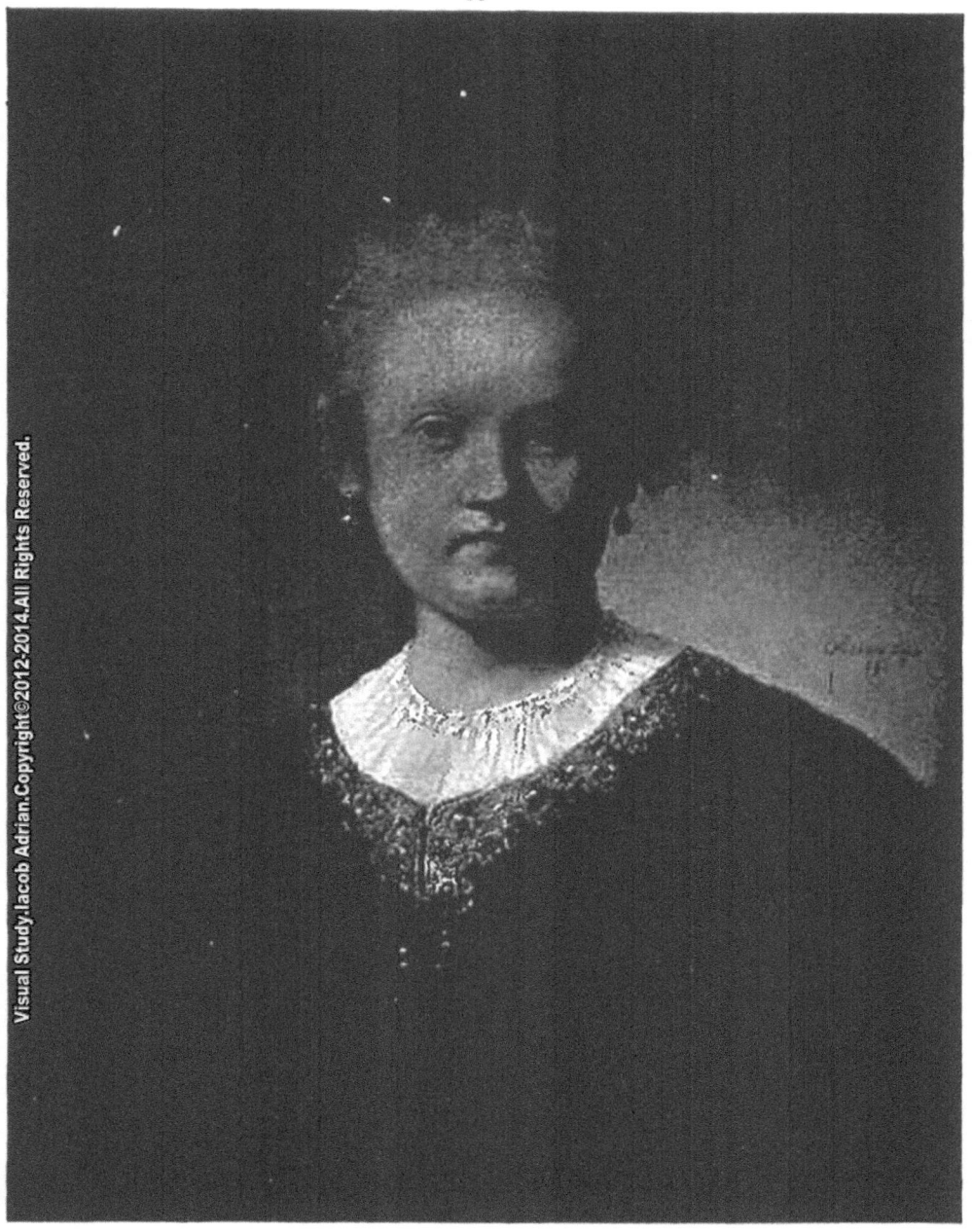

PORTRAIT OF A SISTER OF THE ARTIST (?)
(*Liechtenstein Gallery, Vienna*)

LA SŒUR DE L'ARTISTE (?)
(*Galerie Liechtenstein, Vienne*)

BILDNIS DER SCHWESTER DES KÜNSTLERS
(*Wien, Galerie Liechtenstein*)
F. Hanfstaengl, Photo.

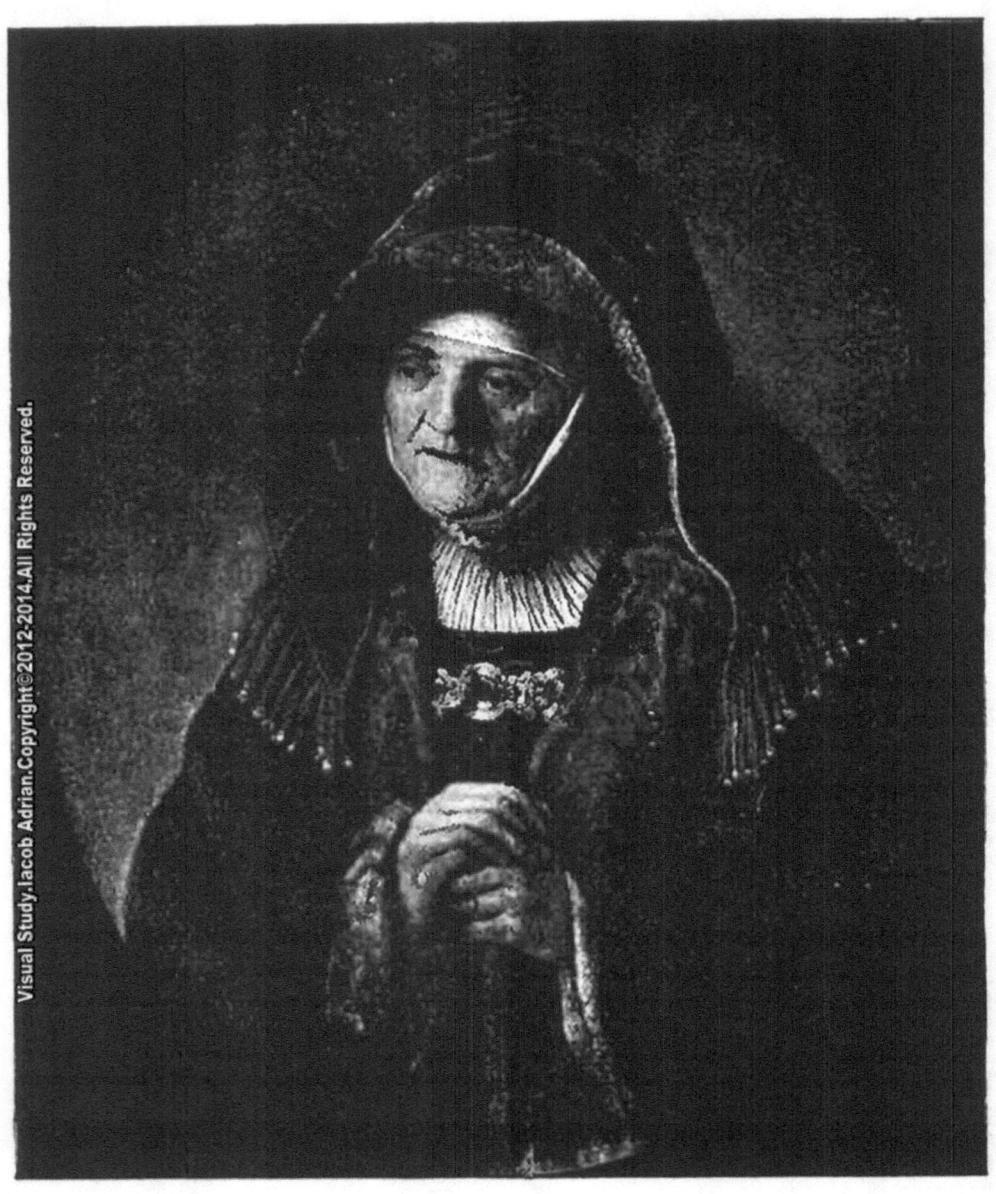

REMBRANDT'S MOTHER
(*Imperial Gallery, Vienna*)

LA MÈRE DE REMBRANDT
(*Galerie impériale, Vienne*)

REMBRANDTS MUTTER
(*Wien, Kaiserl. Galerie*)
F. Hanfstaengl, Photo.

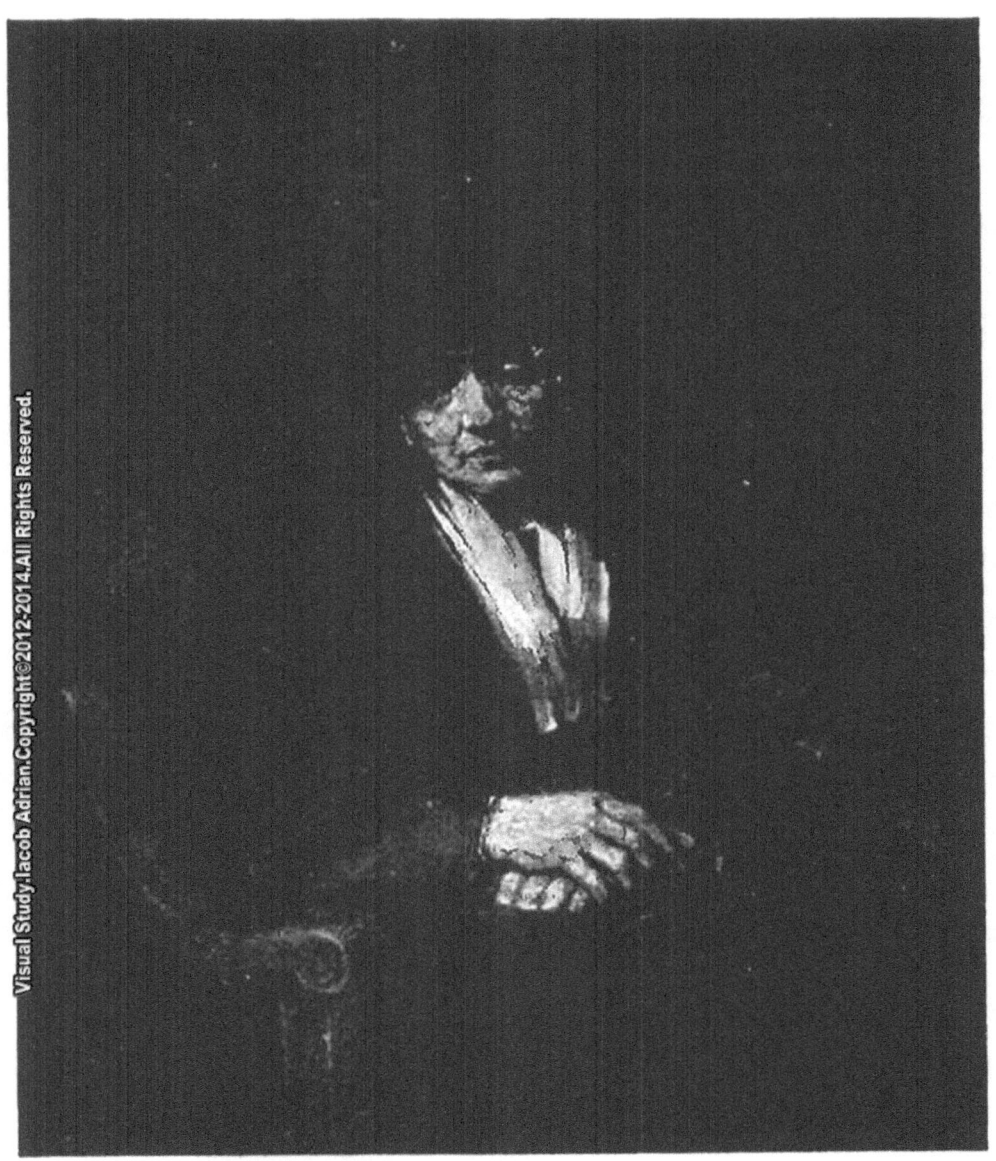

Portrait of an Old Woman La Mère de Rembrandt (?)
(Rembrandt's Mother?) (*L'Ermitage, Saint-Pétersbourg*)
(*The Hermitage, St. Petersburg*)
Bildnis einer alten Frau (Rembrandts Mutter?)
(*Petersburg, Eremitage*)
F. Hanfstaengl, Photo.

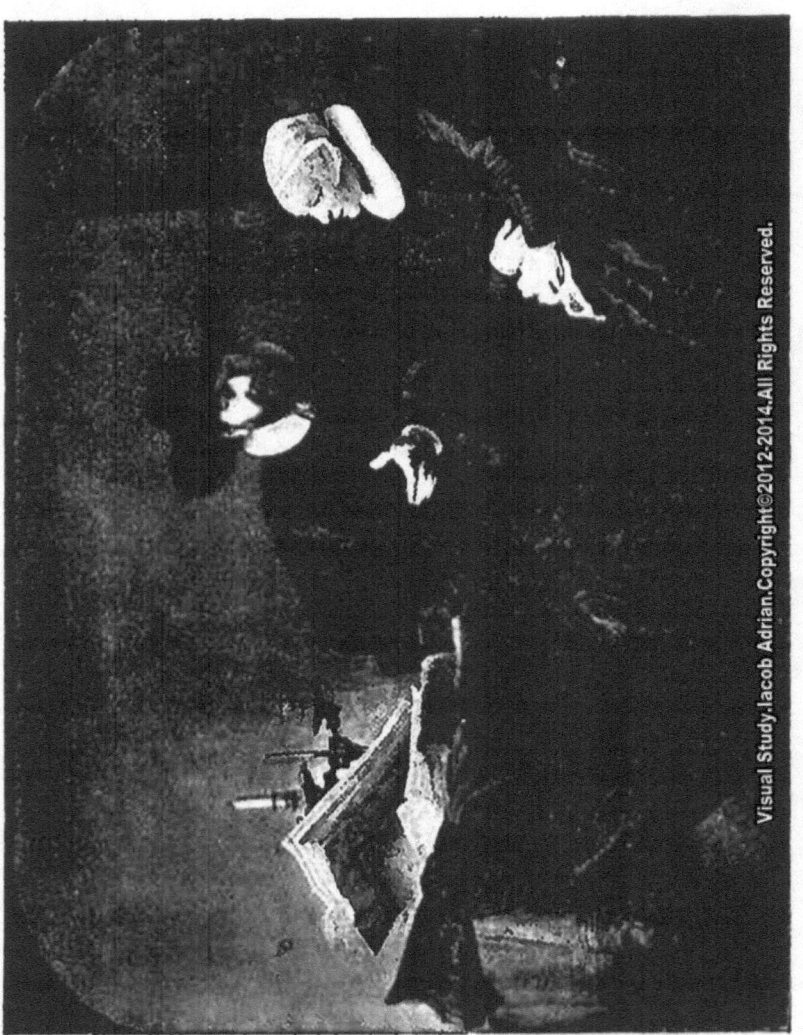

Pastor Anslo and his Wife Le Pasteur Anslo et sa Femme
(Royal Gallery, Berlin) (Musée royal, Berlin)
Der Mennonitenprediger Anslo und seine Frau
(Berlin, Kgl. Galerie)
F. Hanfstaengl, Photo.

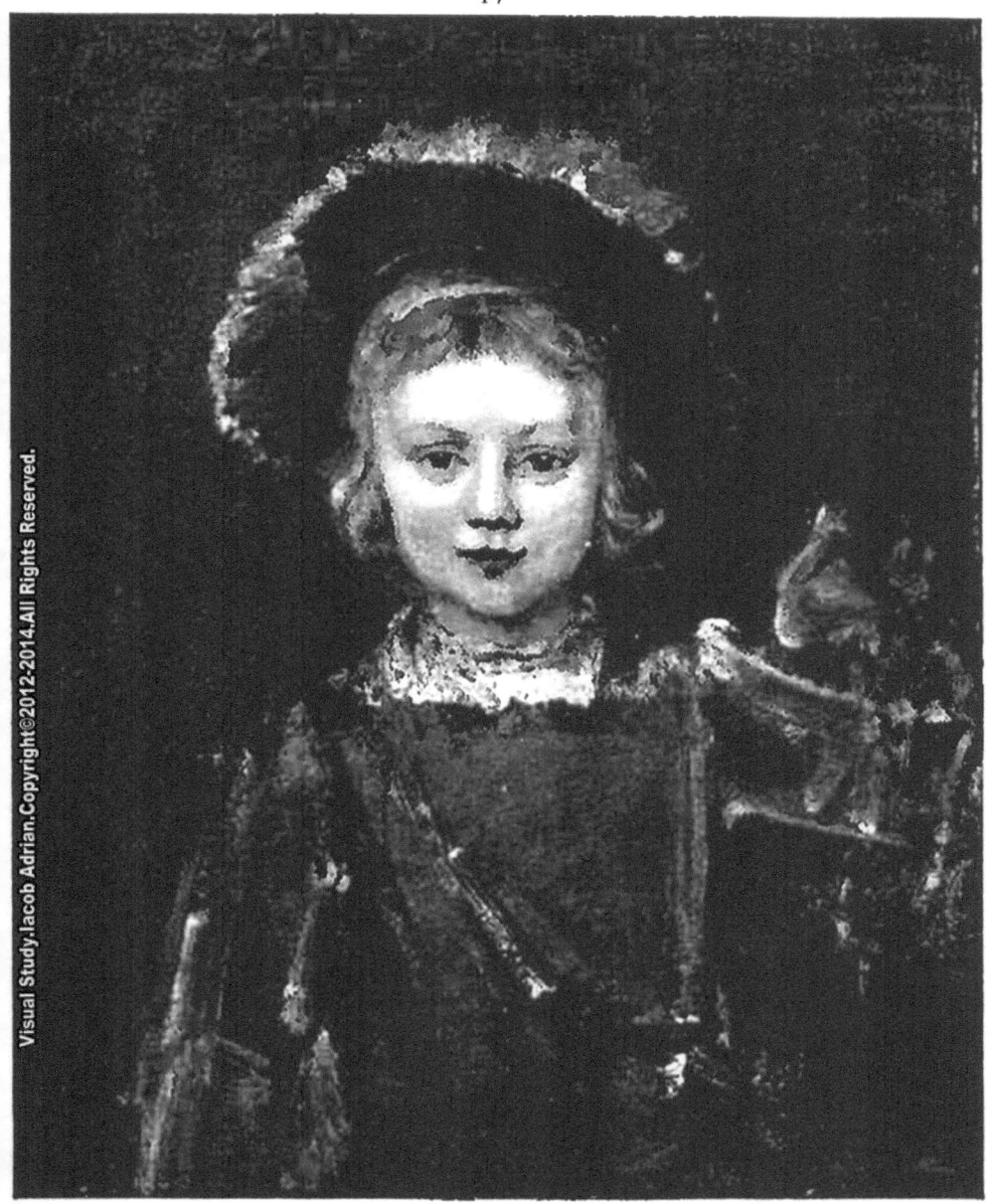

WILLIAM PRINCE OF ORANGE, GUILLAUME D'ORANGE, PLUS TARD
AFTERWARDS WILLIAM III. (Unfinished) GUILLAUME III. (Inachevé)
(*Earl Spencer, Althorp*) (*Comte Spencer, Althorp*)
WILHELM, PRINZ VON ORANIEN, SPÄTER WILHELM III.
(Unbeendet)
(*Althorp, Graf Spencer*)
F. *Hanfstaengl, Photo.*

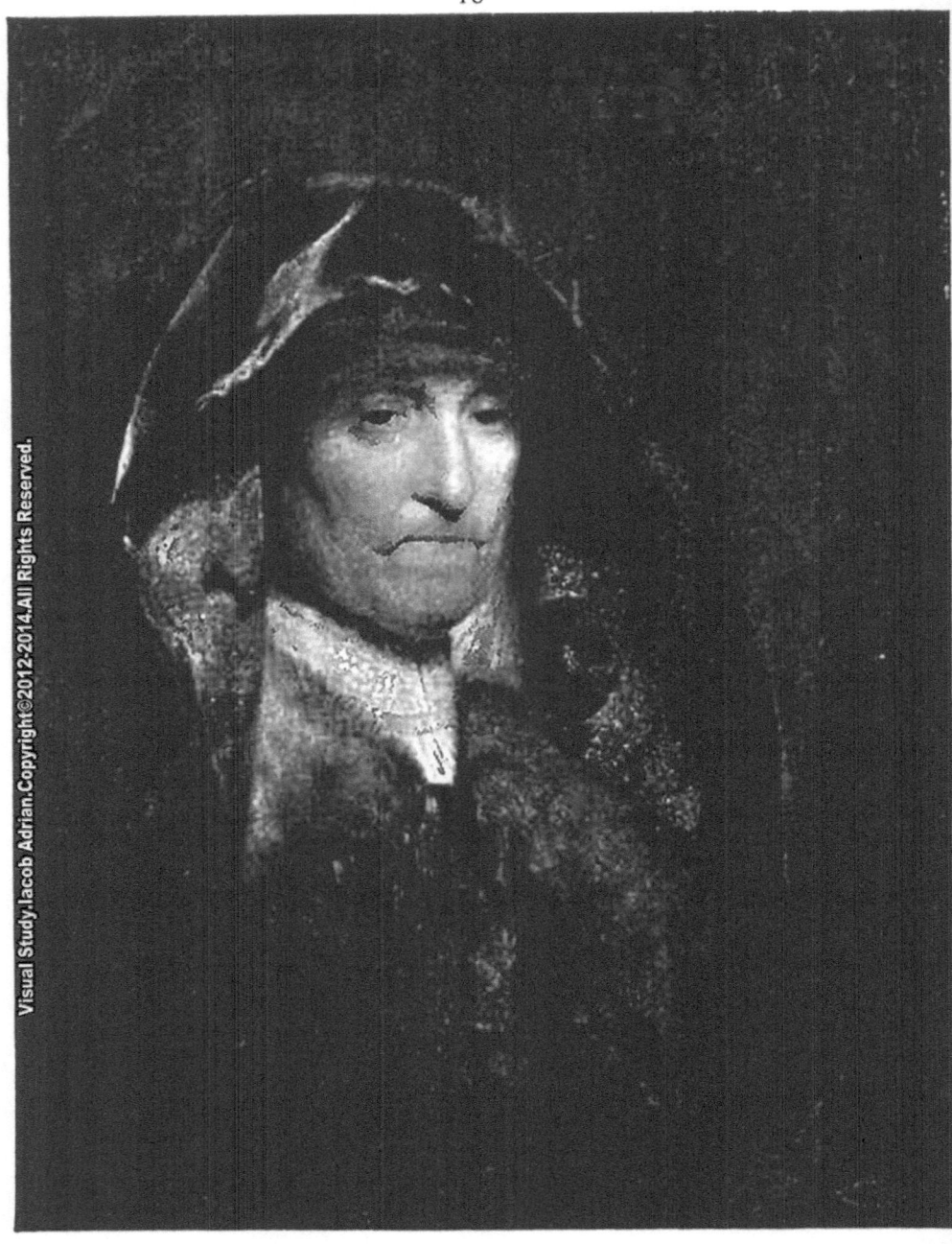

THE COUNTESS OF DESMOND　　LA COMTESSE DE DESMOND
(*Windsor Castle*)　　　　　　(*Galerie royale, Windsor*)
BILDNIS DER GRÄFIN VON DESMOND
(*Windsor, Kgl. Schloss*)
F. Hanfstaengl, Photo.

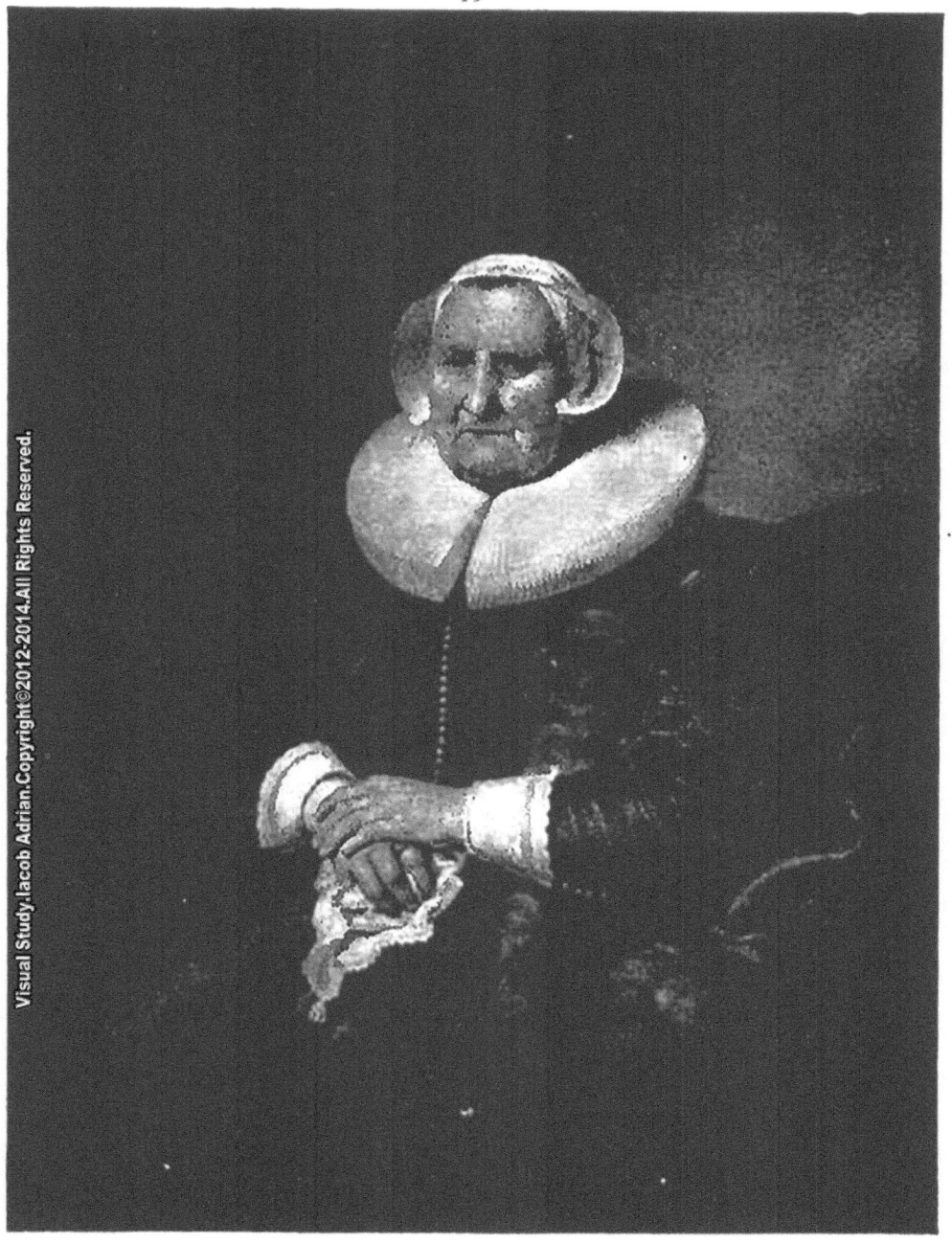

ELISABETH BAS
(Royal Museum, Amsterdam)

ÉLISABETH BAS
(Musée royal, Amsterdam)

BILDNIS DER ELISABETH JAKOBS BAS
(Amsterdam, Kgl. Museum)
F. Hanfstaengl, Photo.

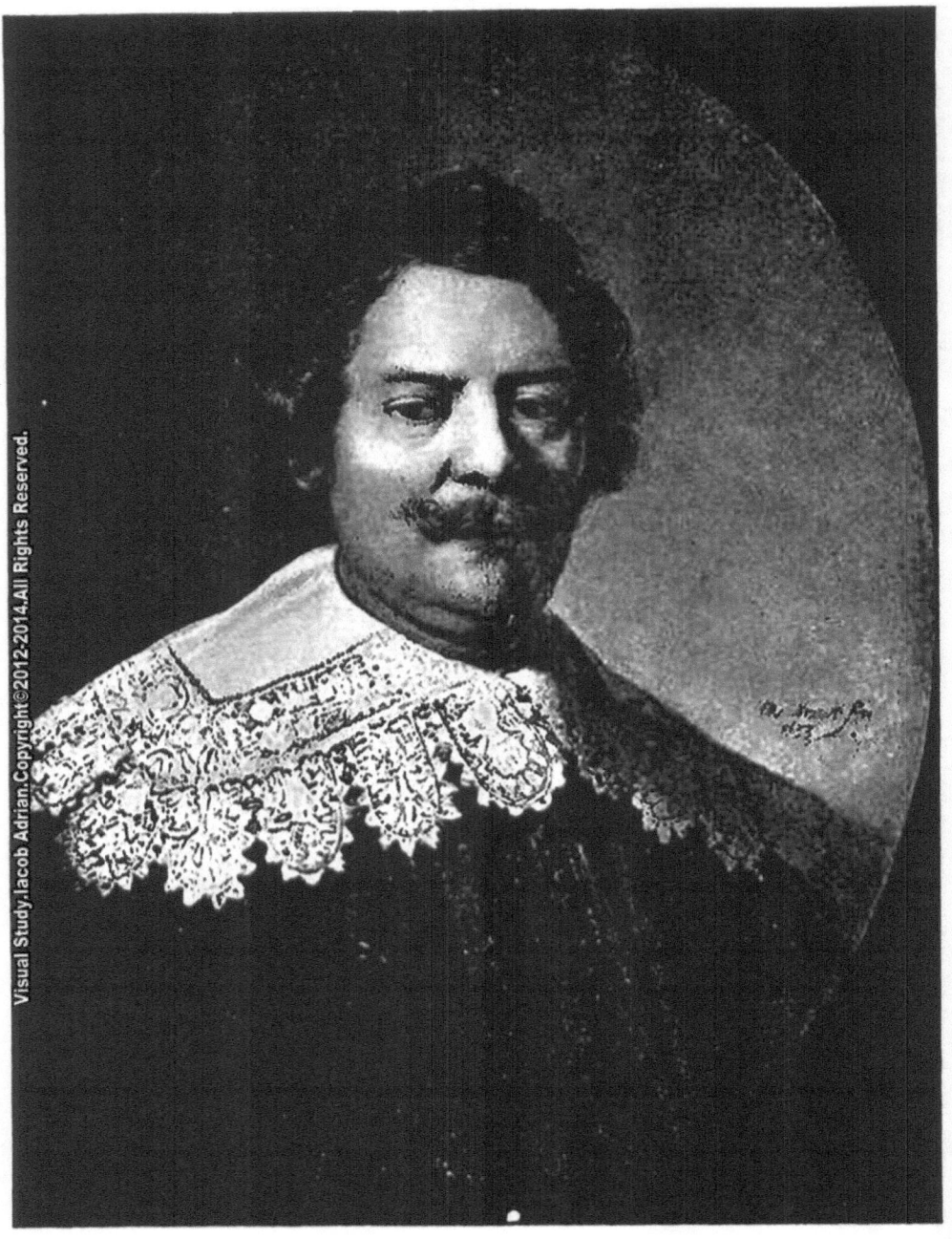

WILLEM BURGGRAEFF
(*Royal Gallery, Dresden*)

WILLEM BURGGRAEFF
(*Galerie royale, Dresde*)

BILDNIS DES WILLEM BURGGRAEFF
(*Dresden, Kgl. Galerie*)
F. Hanfstaengl, Photo.

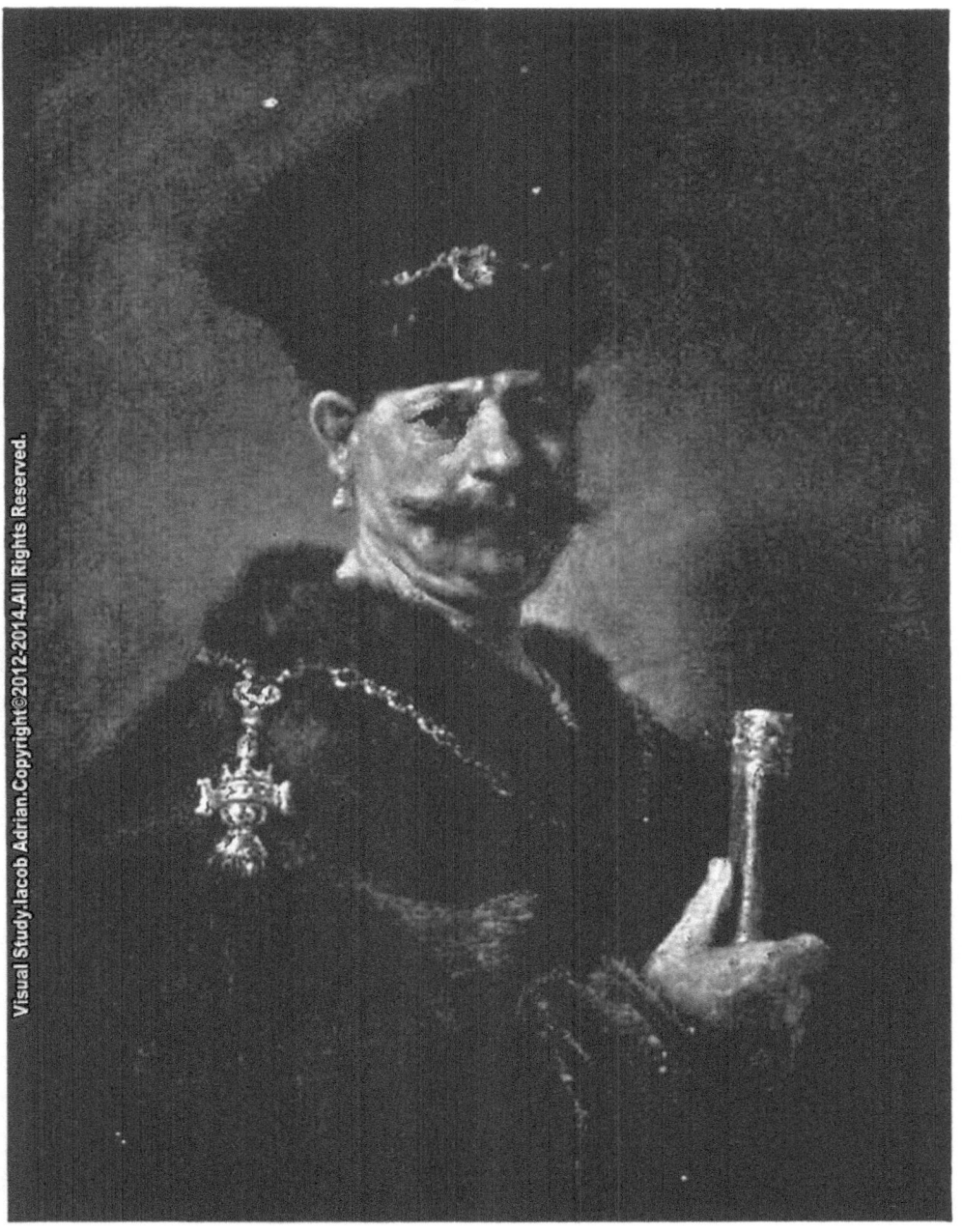

JOHN SOBIESKI, JEAN SOBIESKI,
KING OF POLAND (?) ROI DE POLOGNE (?)
(*The Hermitage, St. Petersburg*) (*L'Ermitage, Saint-Pétersbourg*)
MÄNNLICHES BILDNIS, ANGEBLICH JOHANN SOBIESKI,
KÖNIG VON POLEN
(*Petersburg, Eremitage*)
F. Hanfstaengl, Photo.

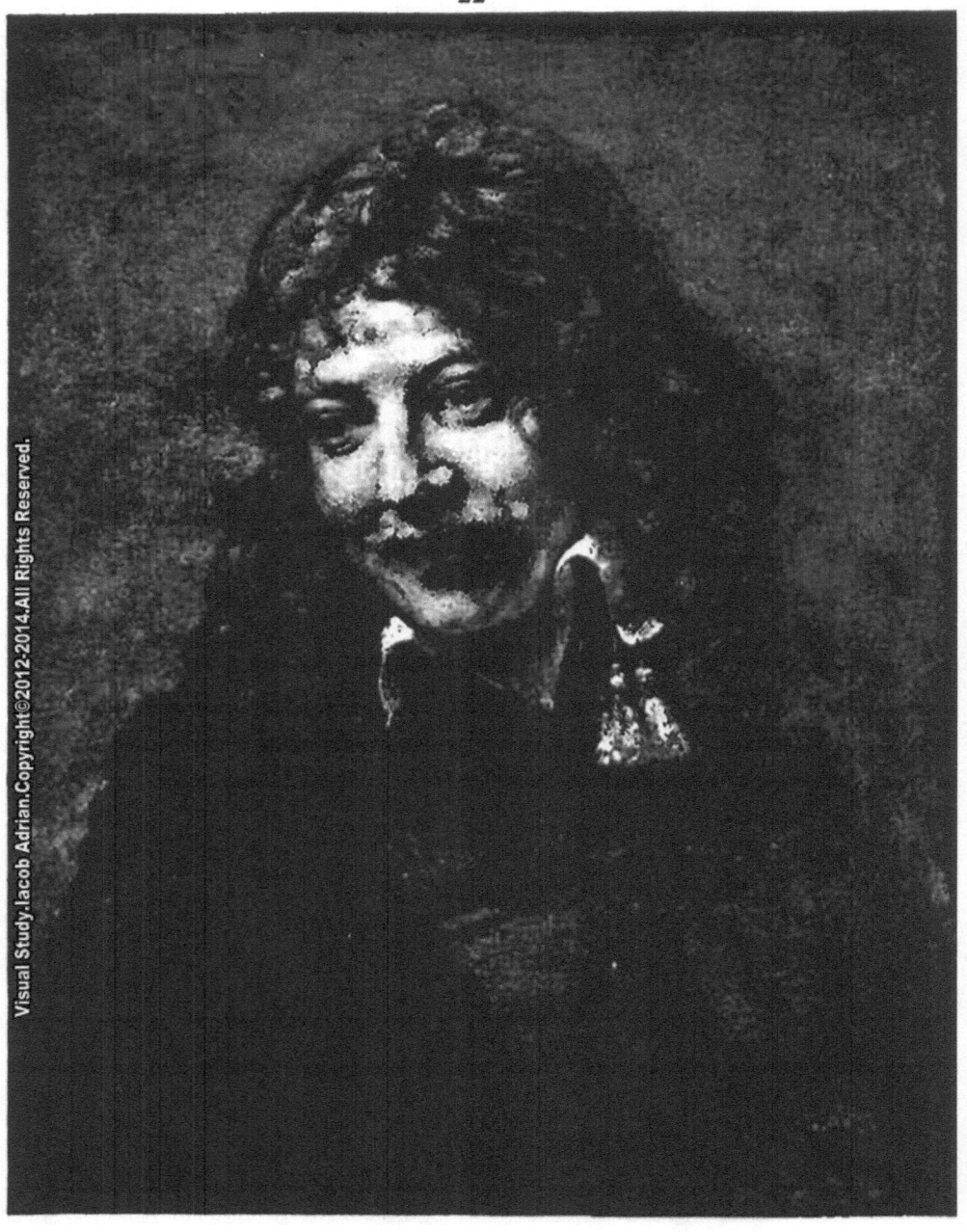

PORTRAIT OF
NIKOLAUS BRUYNINGH (?)
(*Royal Gallery, Cassel*)

PORTRAIT DE
NIKOLAUS BRUYNINGH (?)
(*Galerie royale, Cassel*)

BILDNIS, ANGEBLICH DES NIKOLAUS BRUYNINGH
(*Cassel, Kgl. Galerie*)
F. Hanfstaengl, Photo.

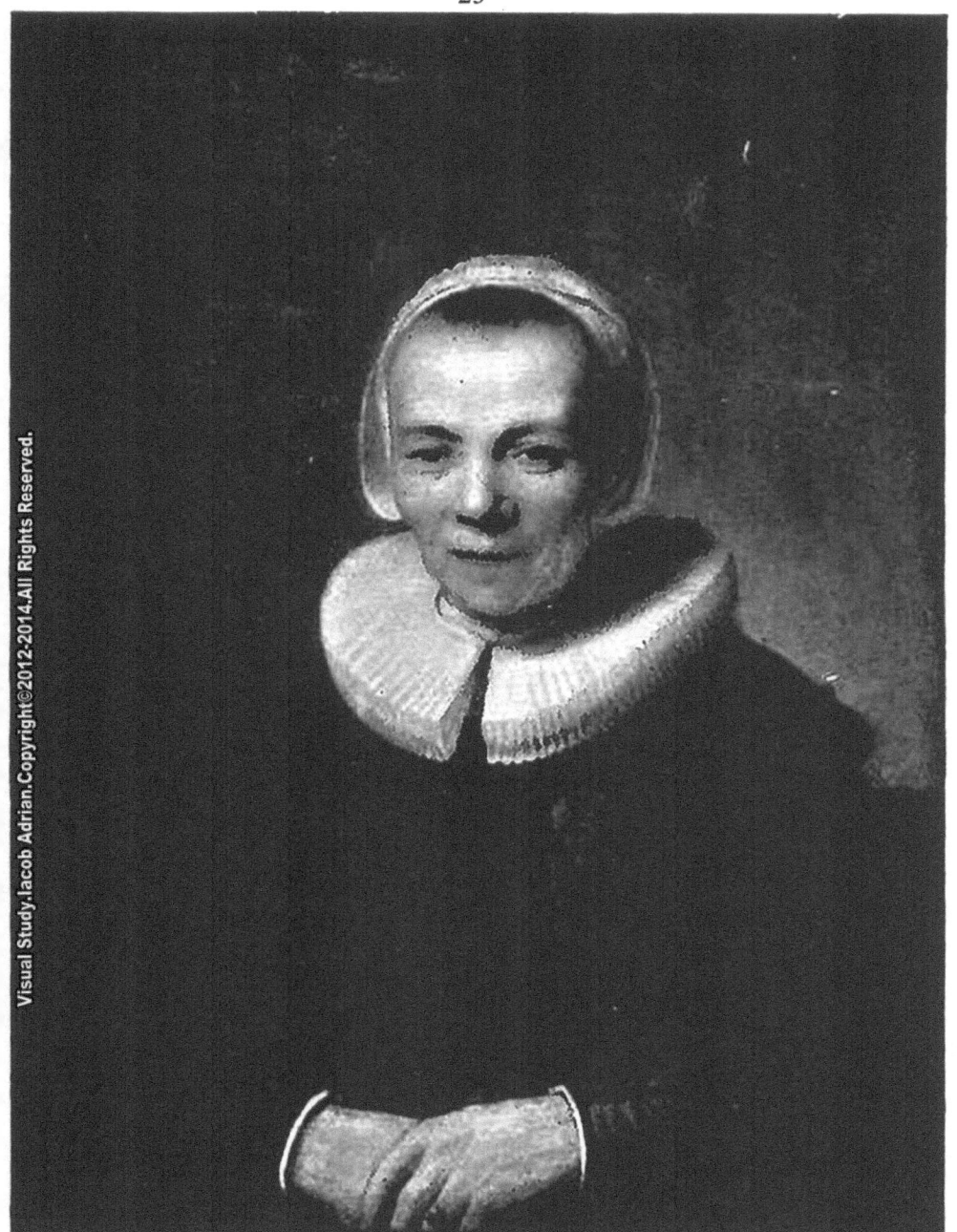

PORTRAIT OF AN OLD WOMAN PORTRAIT D'UNE FEMME AGÉE
(*The Hermitage, St. Petersburg*) (*L'Ermitage, Saint-Pétersbourg*)
BILDNIS EINER ALTEN FRAU
(*Petersburg, Eremitage*)
F. Hanfstaengl, Photo.

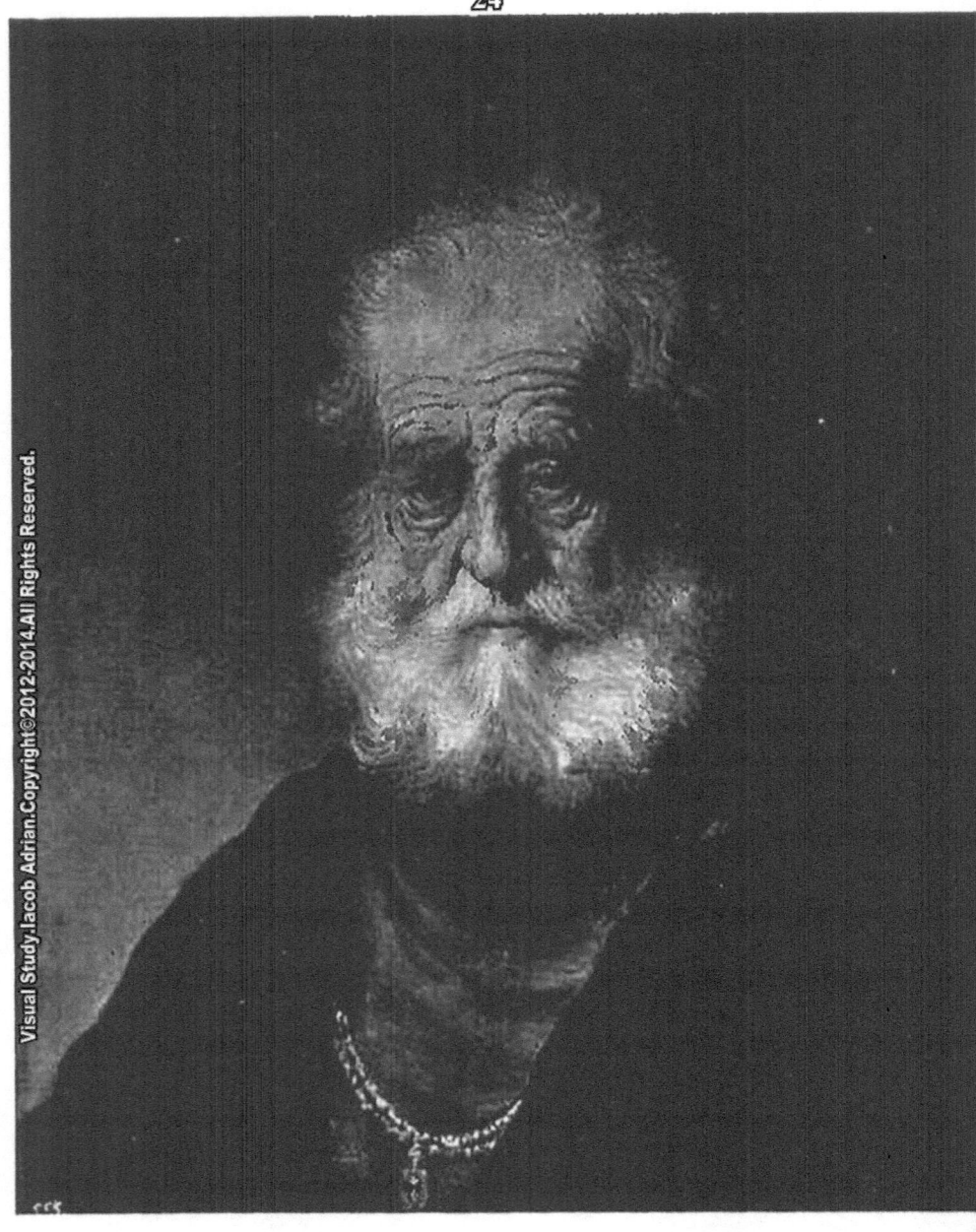

THE "MAN WITH THE COPPER-
COLOURED NOSE"
(Royal Gallery, Cassel)

PORTRAIT D'HOMME
(Galerie royale, Cassel)

DER "MANN MIT DER KUPFERNASE"
(Cassel, Kgl. Galerie)
F. Hanfstaengl, Photo.

BOY SINGING
(*Imperial Gallery, Vienna*)
GARÇON CHANTANT
(*Galerie impériale, Vienne*)
DER SINGENDE JÜNGLING
(*Wien, Kaiserl. Galerie*)
F. Hanfstaengl, Photo.

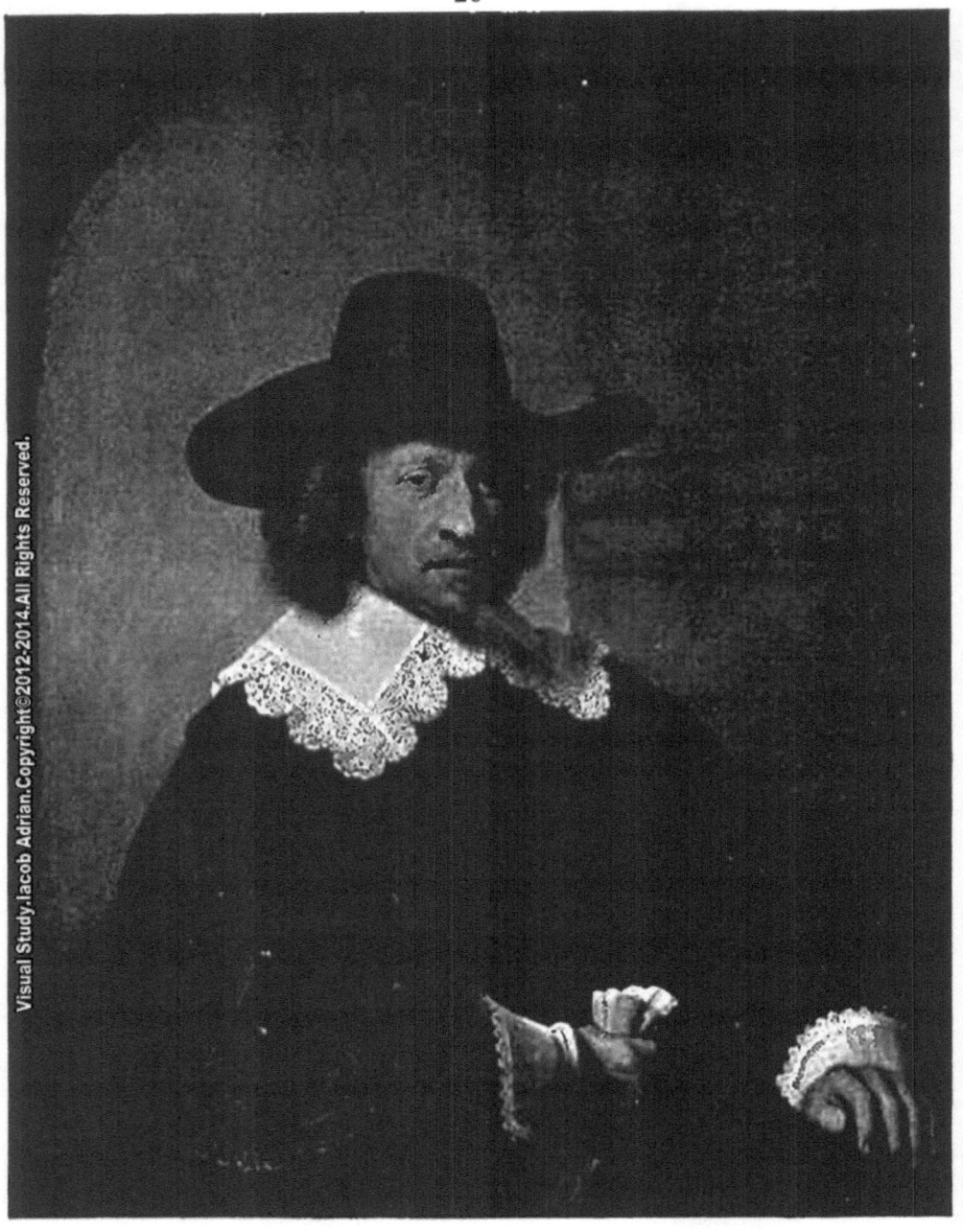

PORTRAIT OF A MAN
(*Royal Museum, Brussels*)

PORTRAIT D'HOMME
(*Musée royal, Bruxelles*)

MÄNNLICHES BILDNIS
(*Brüssel, Kgl. Museum*)
F. Hanfstaengl, Photo.

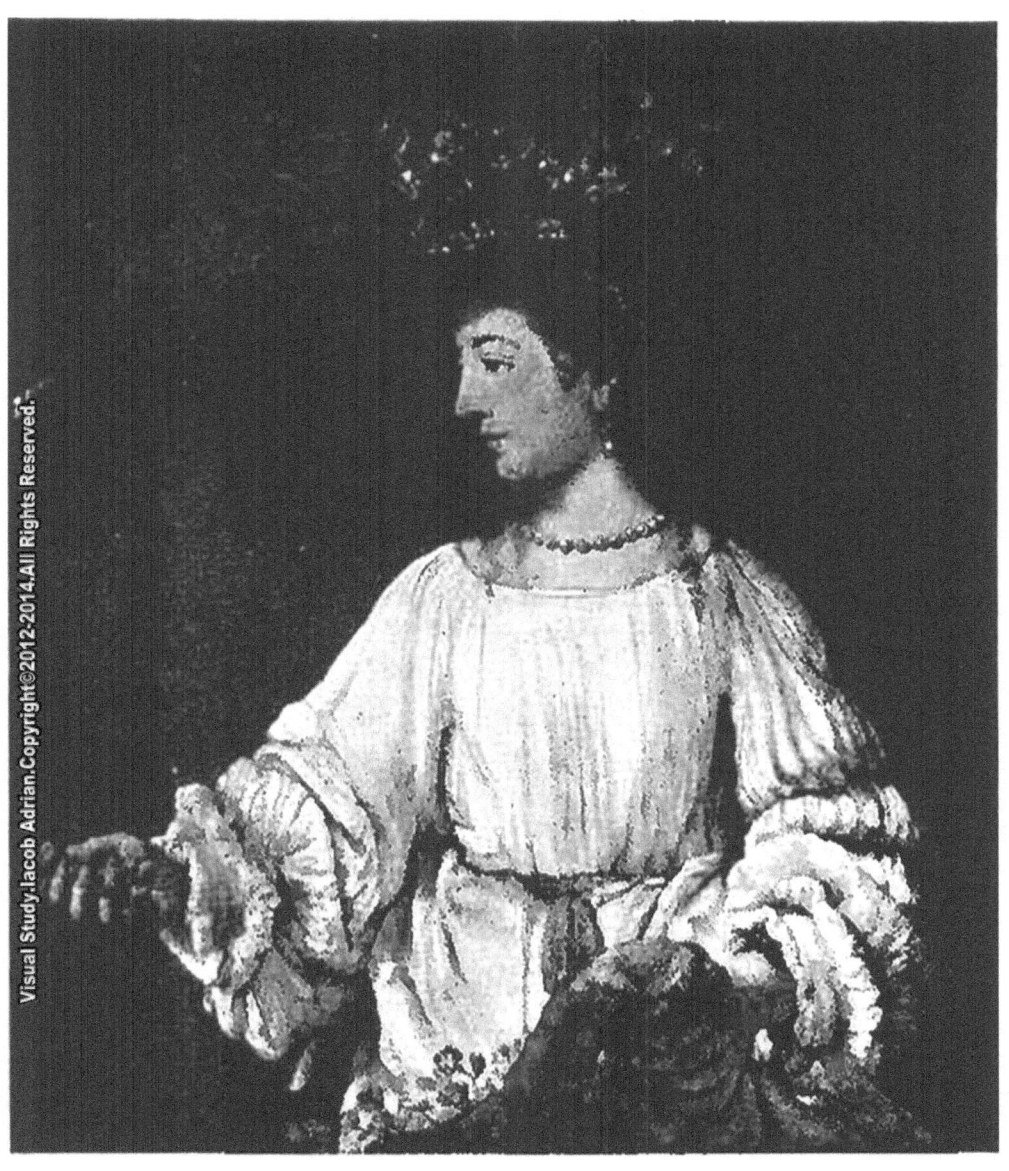

PORTRAIT OF A LADY
(*Earl Spencer, Althorp*)

PORTRAIT D'UNE DAME
(*Comte Spencer, Althorp*)

BILDNIS EINER FRAU
(*Althorp, Graf Spencer*)
F. Hanfstaengl, Photo.

PORTRAIT OF A YOUNG MAN　　　PORTRAIT D'UN JEUNE HOMME
　　　　WITH A HAT　　　　　　　　　AVEC CHAPEAU
　(The Hermitage, St. Petersburg)　(L'Ermitage, Saint-Pétersbourg)
　　BILDNIS EINES JUNGEN MANNES MIT HUT
　　　　　　(Petersburg, Eremitage)
　　　　　　F. Hanfstaengl, Photo.

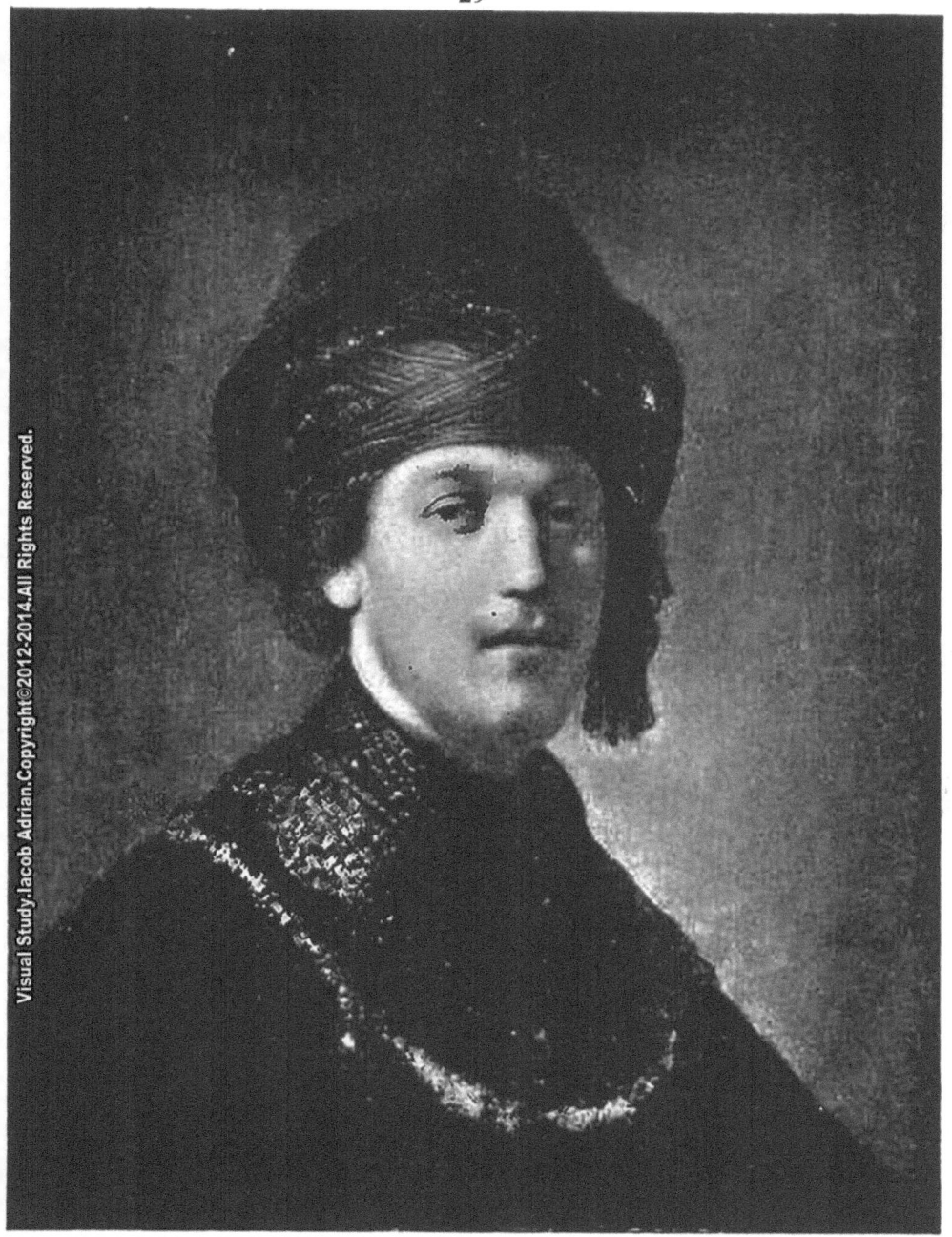

PORTRAIT OF A YOUNG MAN PORTRAIT D'UN JEUNE HOMME
(*Windsor Castle*) (*Galerie royale, Windsor*)
BILDNIS EINES JUNGEN MANNES
(*Windsor, Kgl. Schloss*)
F. Hanfstaengl, Photo.

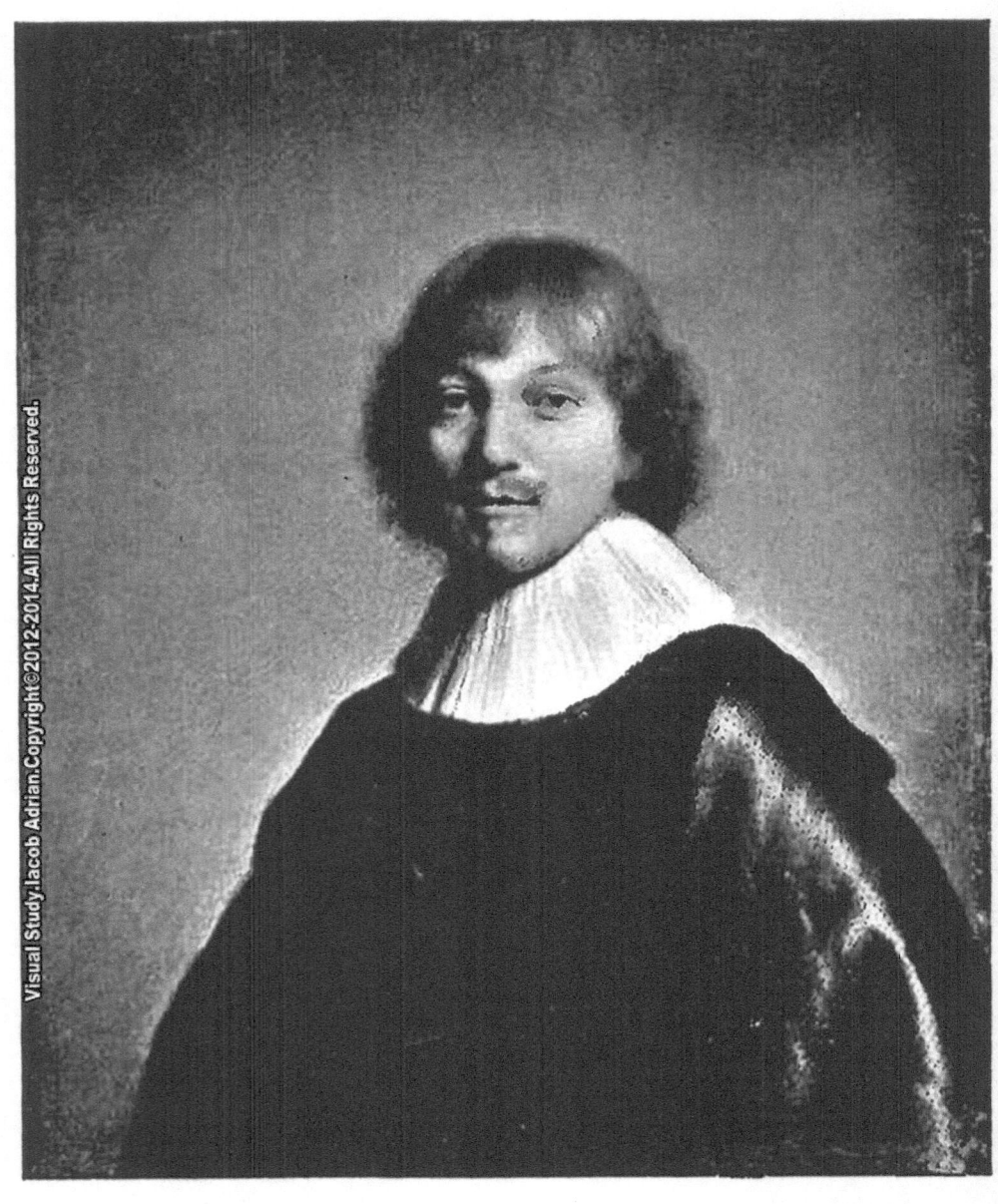

PORTRAIT OF A YOUNG MAN PORTRAIT D'UN JEUNE HOMME
(*Dulwich Gallery*) (*Galerie, Dulwich*)
BILDNIS EINES JUNGEN MANNES
(*Dulwich, Galerie*)
F. Hanfstaengl, Photo.

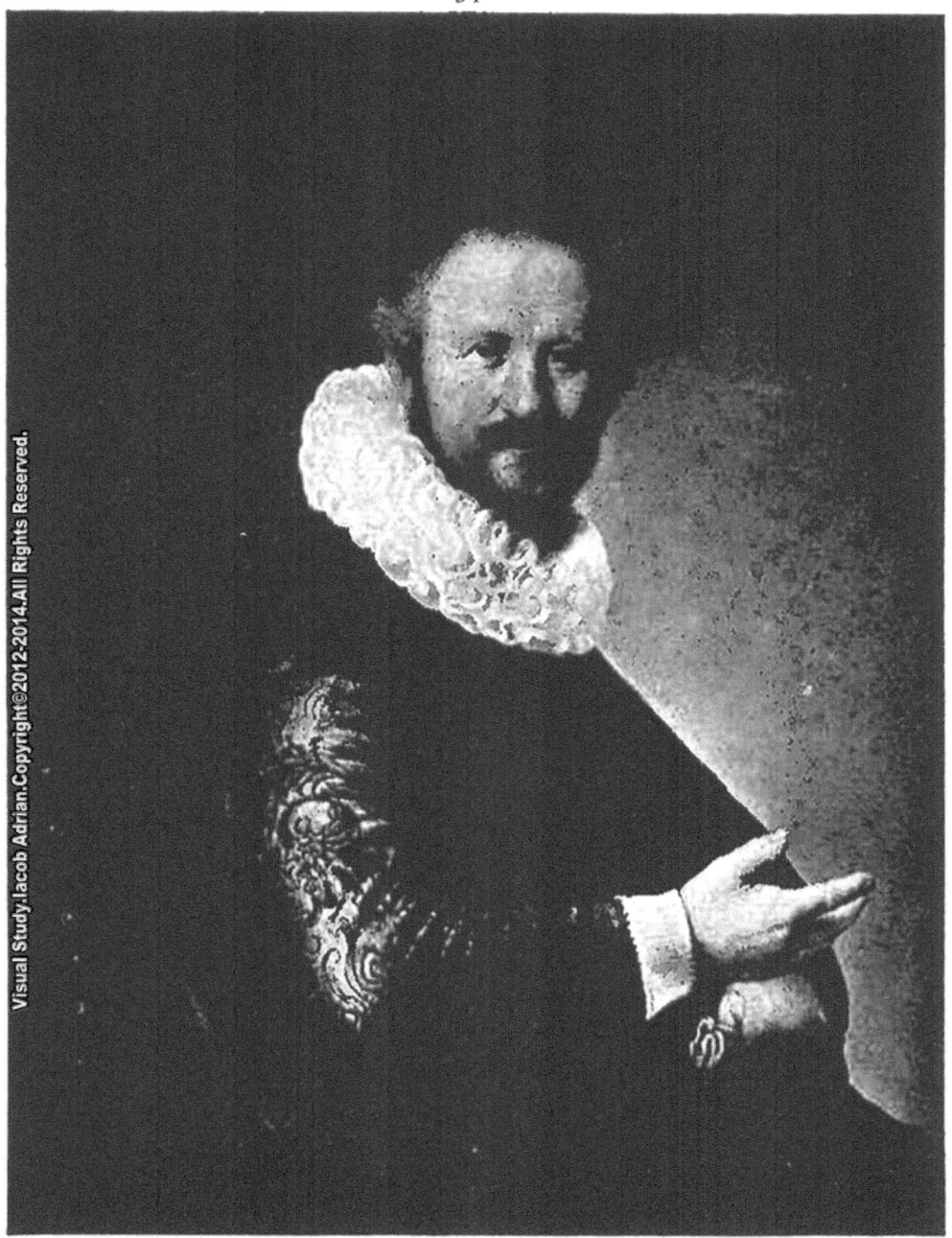

PORTRAIT OF A MAN
(*Imperial Gallery, Vienna*)

PORTRAIT D'HOMME
(*Galerie impériale, Vienne*)

BILDNIS EINES MANNES
(*Wien, Kaiserl. Galerie*)

F. Hanfstaengl, Photo.

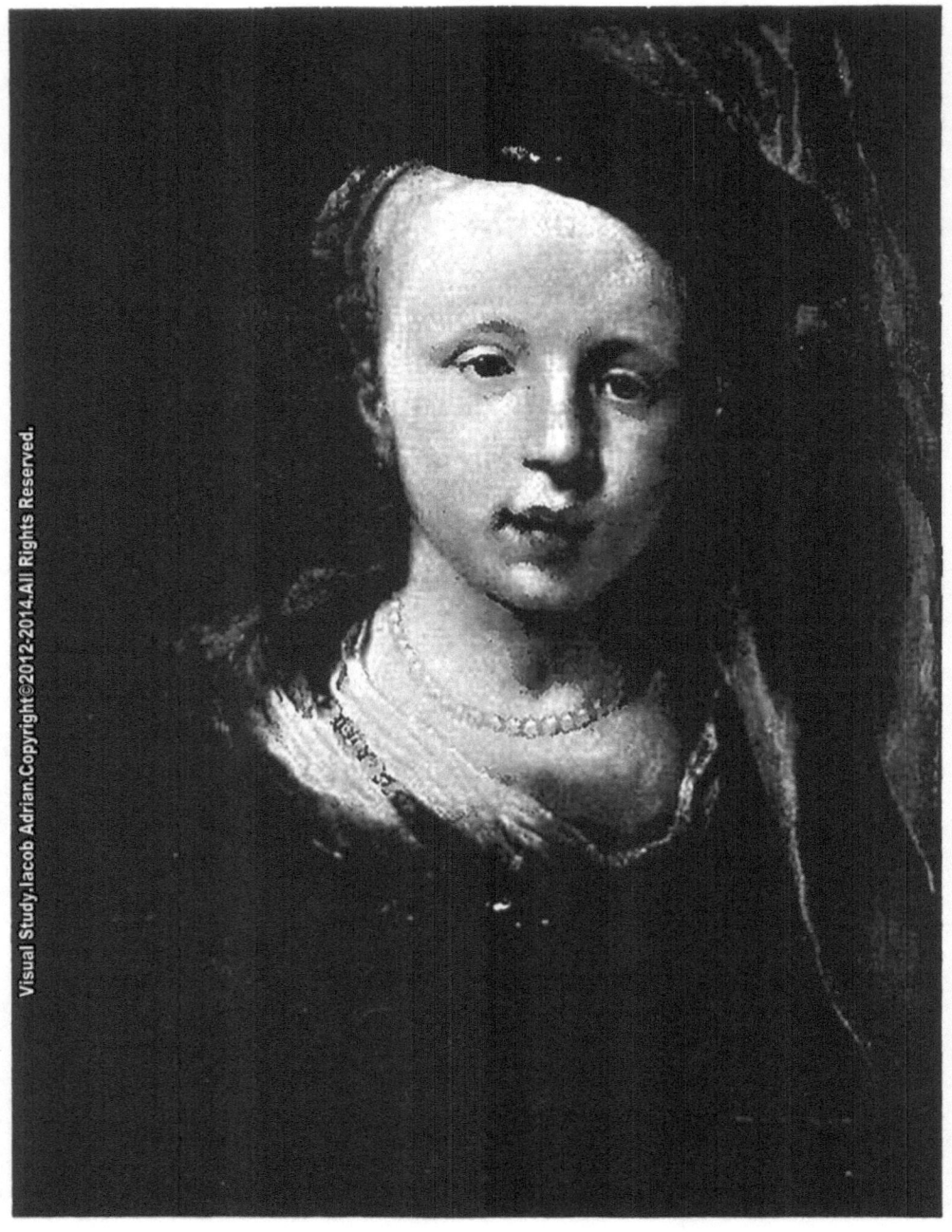

PORTRAIT OF A YOUNG GIRL PORTRAIT D'UNE JEUNE FILLE
(Duke of Devonshire, London) (Duc de Devonshire, Londres)
BILDNIS EINES JUNGEN MÄDCHENS
(London, Herzog von Devonshire)
F. Hanfstaengl, Photo.

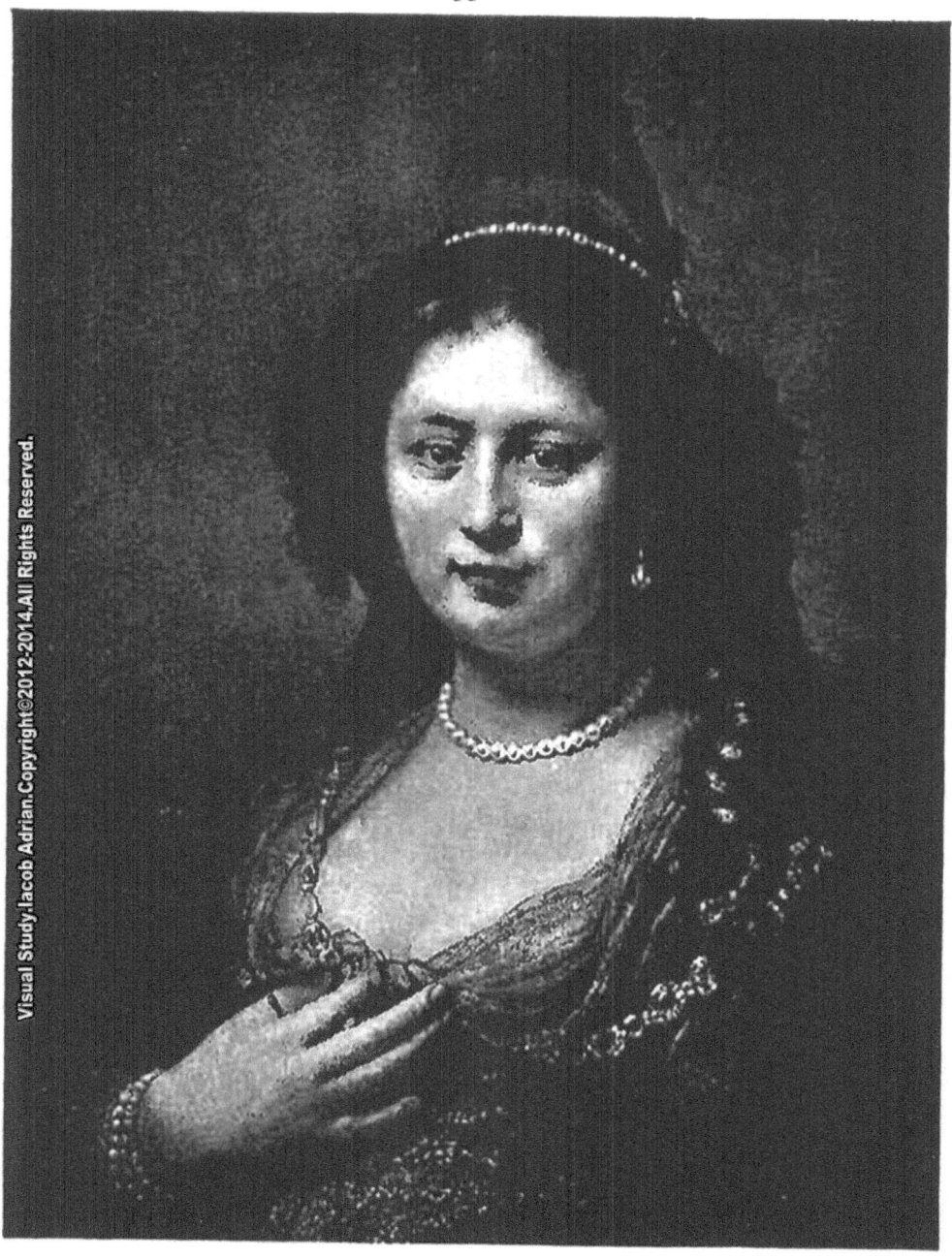

PORTRAIT OF A LADY PORTRAIT D'UNE DAME
(*Liechtenstein Gallery, Vienna*) (*Galerie Liechtenstein, Vienne*)
BILDNIS EINER DAME
(*Wien, Galerie Liechtenstein*)
F. Hanfstaengl, Photo.

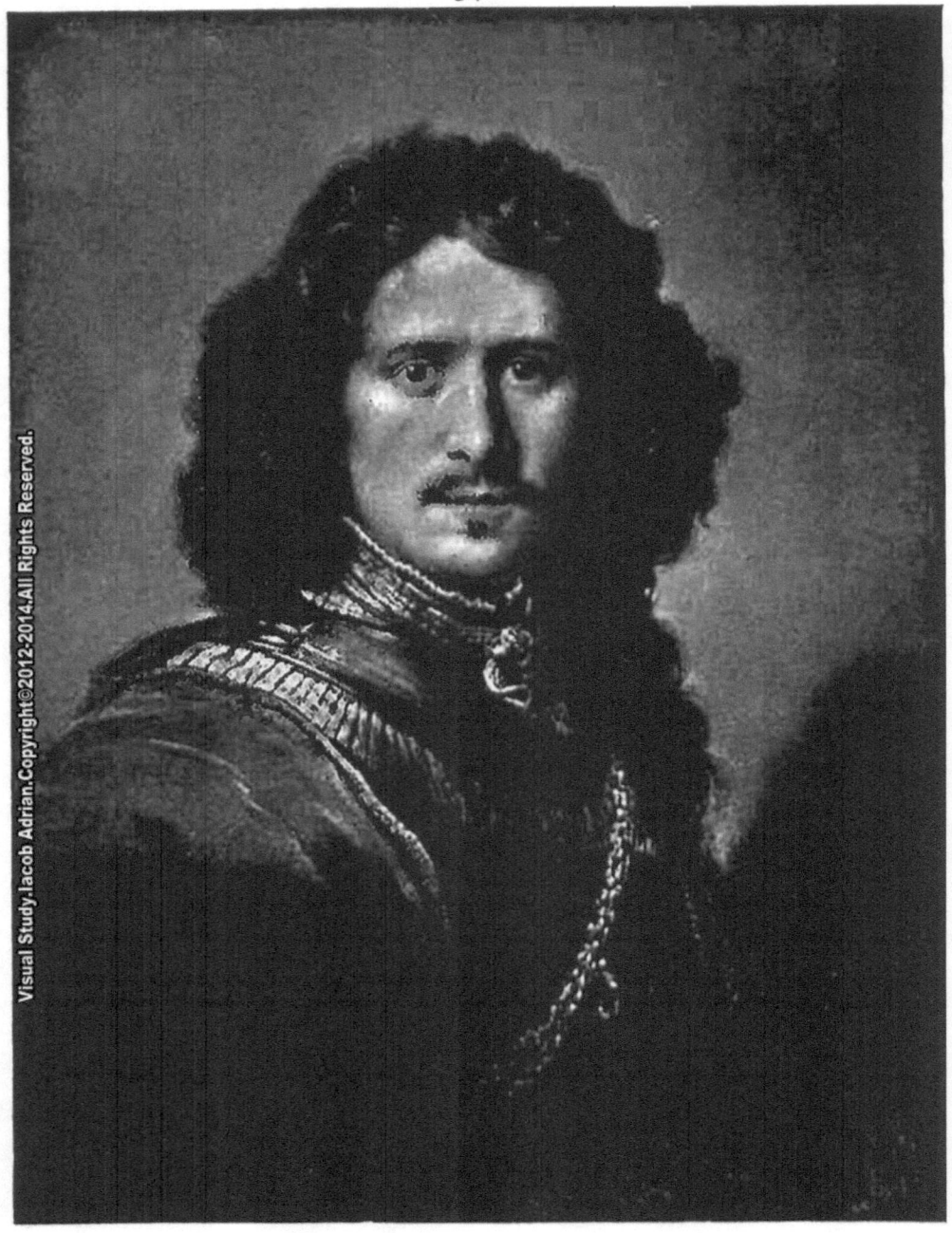

PORTRAIT OF A MAN PORTRAIT D'HOMME
(Liechtenstein Gallery, Vienna) (Galerie Liechtenstein, Vienne)
MÄNNLICHES BILDNIS
(Wien, Galerie Liechtenstein)
F. Hanfstaengl, Photo.

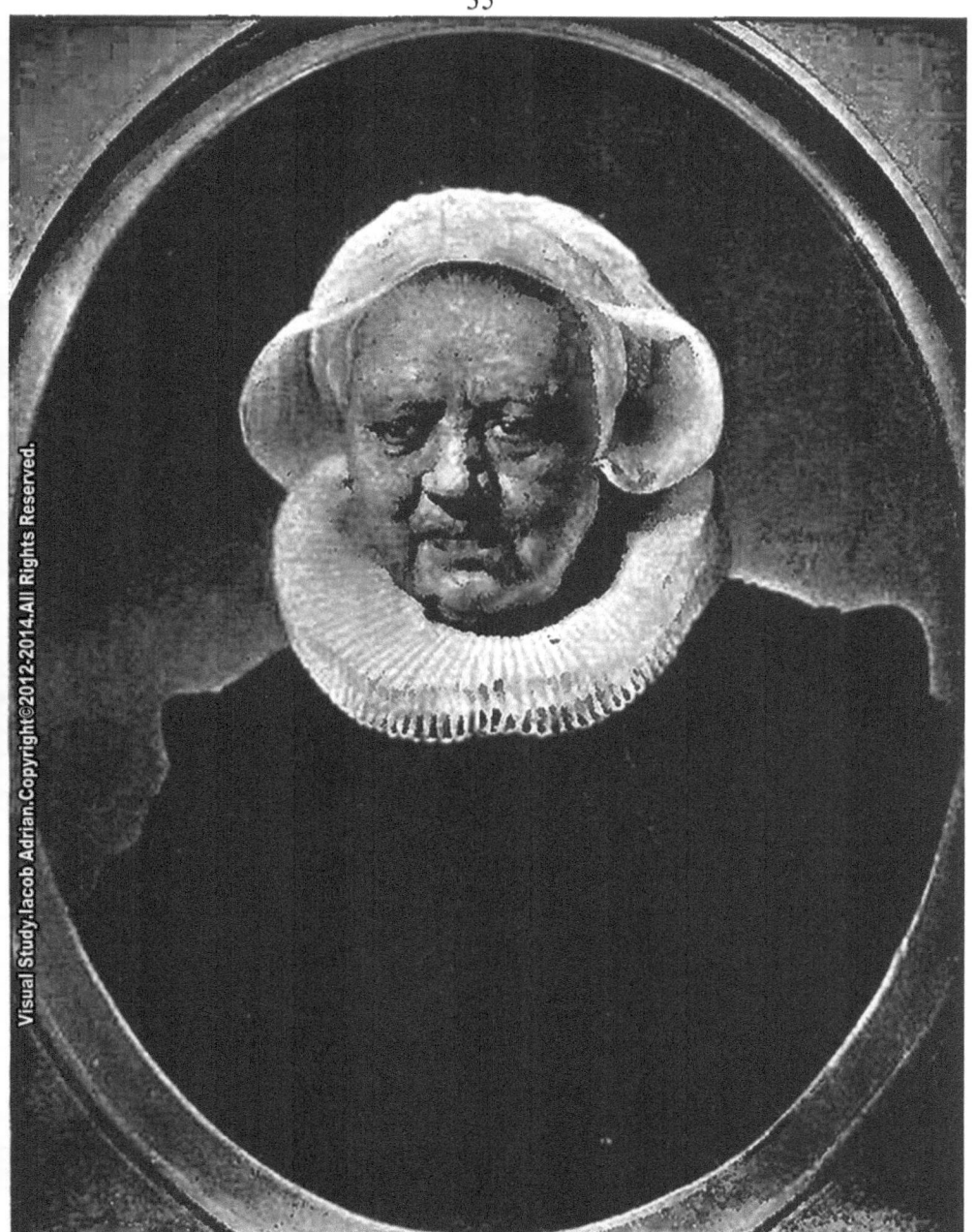

PORTRAIT OF AN OLD LADY
(*National Gallery, London*)

PORTRAIT D'UNE DAME AGÉE
(*Galerie nationale, Londres*)

BILDNIS EINER ALTEN DAME
(*London, Nationalgalerie*)

F. Hanfstaengl, Photo.

PORTRAIT OF A MAN PORTRAIT D'HOMME
(*National Gallery, London*) (*Galerie nationale, Londres*)
MÄNNLICHES BILDNIS
(*London, Nationalgalerie*)
F. Hanfstaengl, Photo.

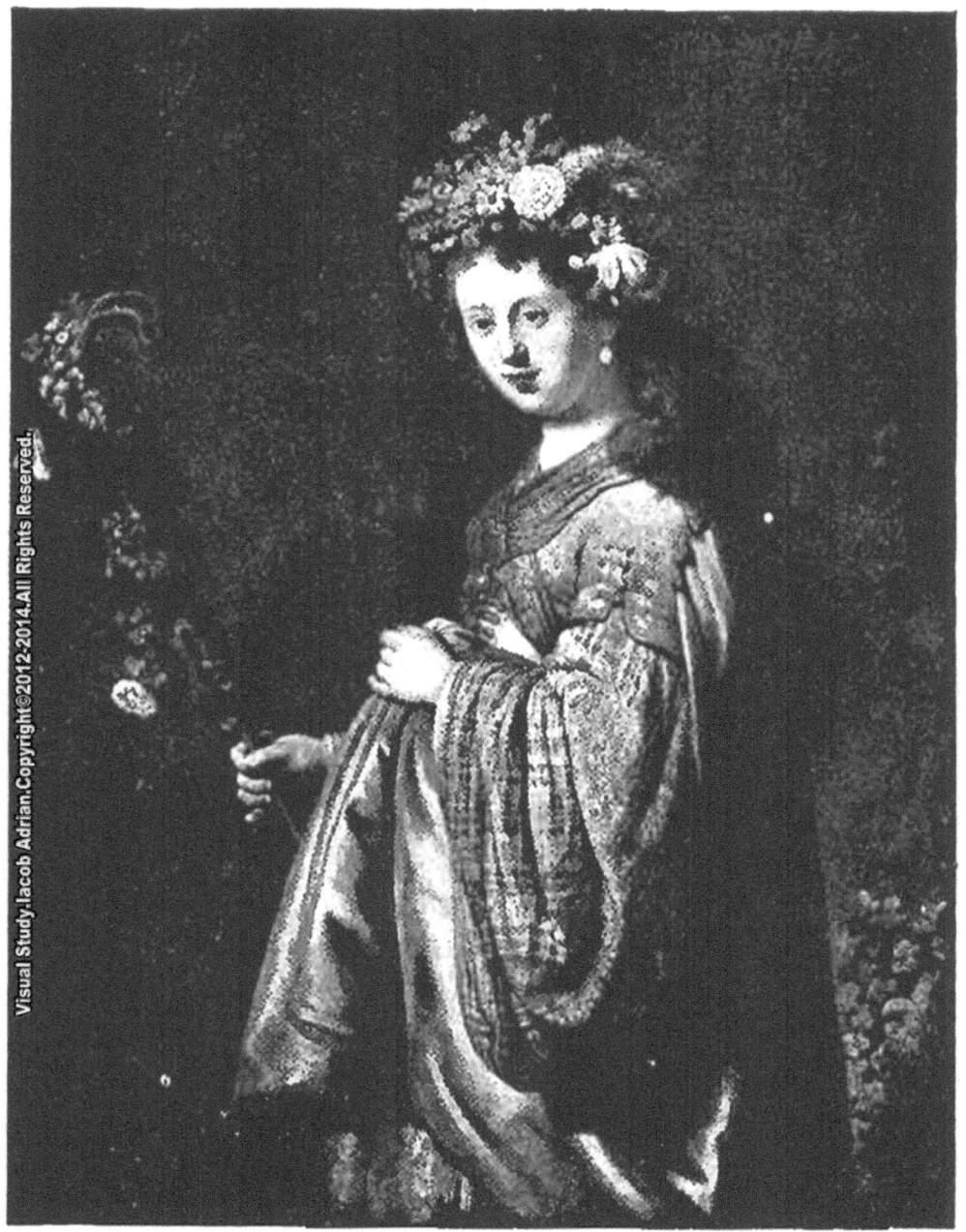

GIRL WITH FLOWERS JEUNE FILLE AVEC FLEURS
(*The Hermitage, St. Petersburg*) (*L'Ermitage, Saint-Pétersbourg*)
JUNGE FRAU MIT BLUMEN
(*Petersburg, Eremitage*)
F. *Hanfstaengl, Photo.*

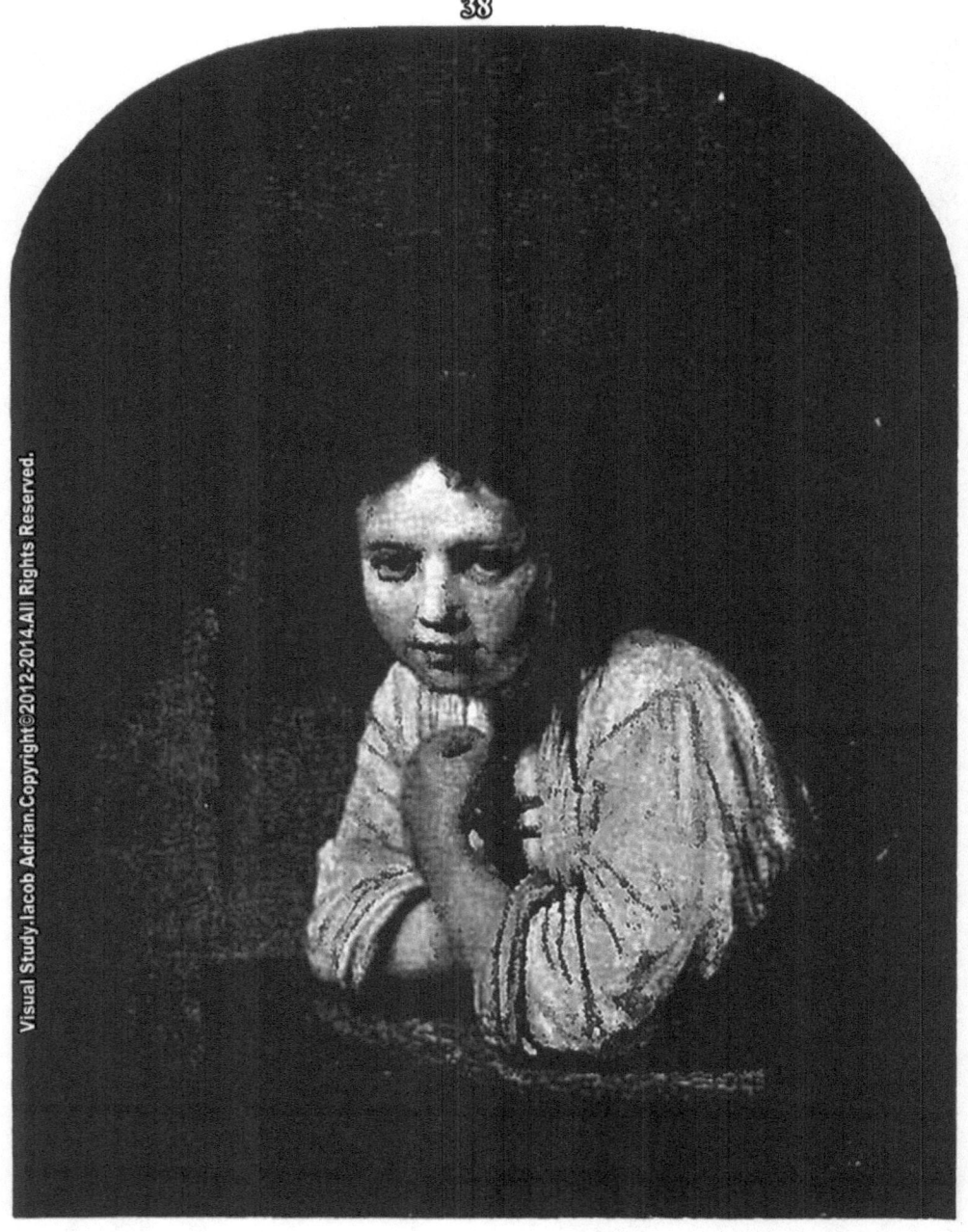

GIRL AT A WINDOW
(Dulwich Gallery)

JEUNE FILLE REGARDANT PAR UNE
FENÊTRE
(Galerie, Dulwich)

EIN MÄDCHEN AN EINEM FENSTER
(Dulwich, Galerie)

F. Hanfstaengl, Photo.

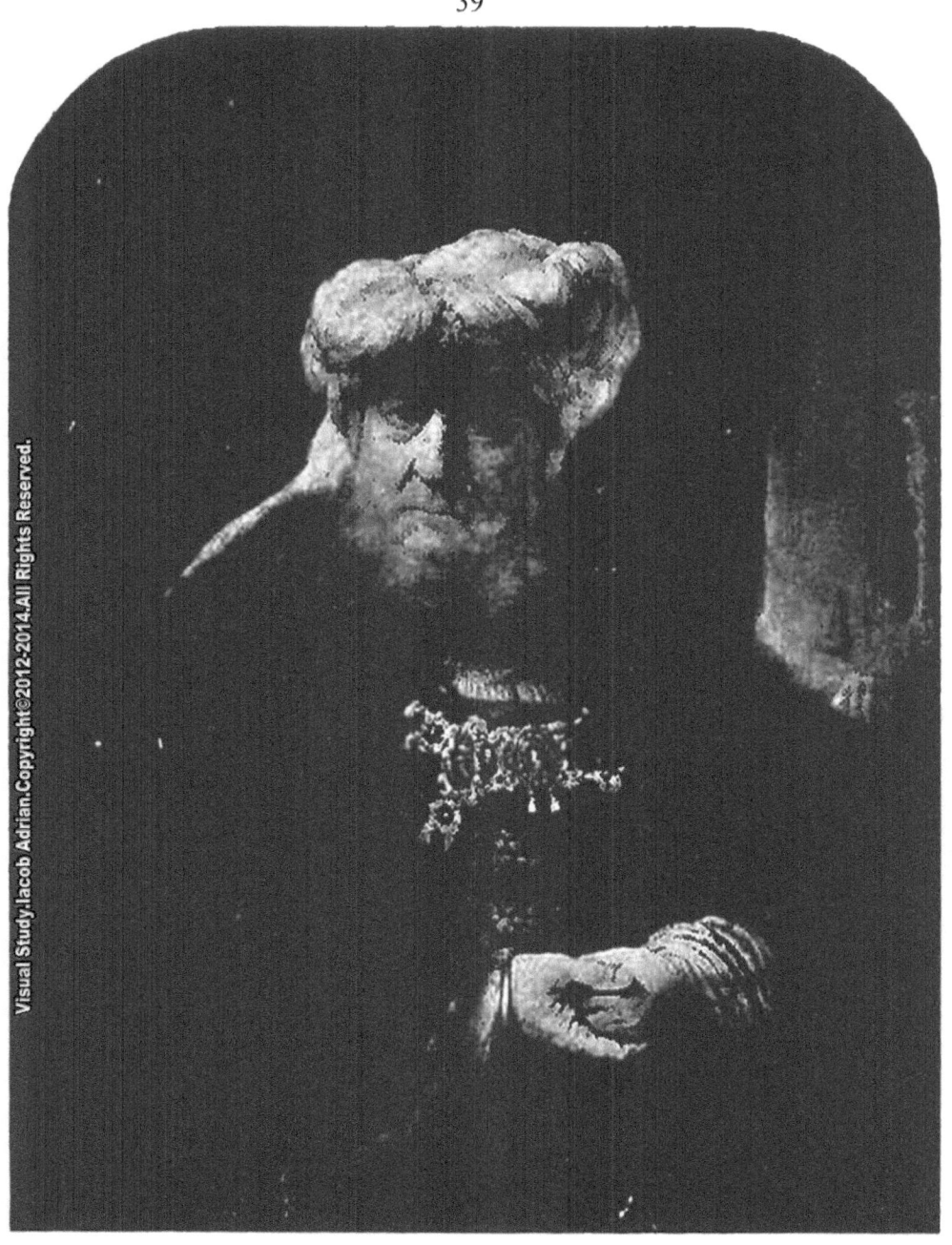

PORTRAIT OF A RABBI PORTRAIT D'UN RABBIN
(*Duke of Devonshire, Chatsworth*) (*Duc de Devonshire, Chatsworth*)
BILDNIS EINES RABBINERS
(*Chatsworth, Herzog von Devonshire*)
F. Hanfstaengl, Photo.

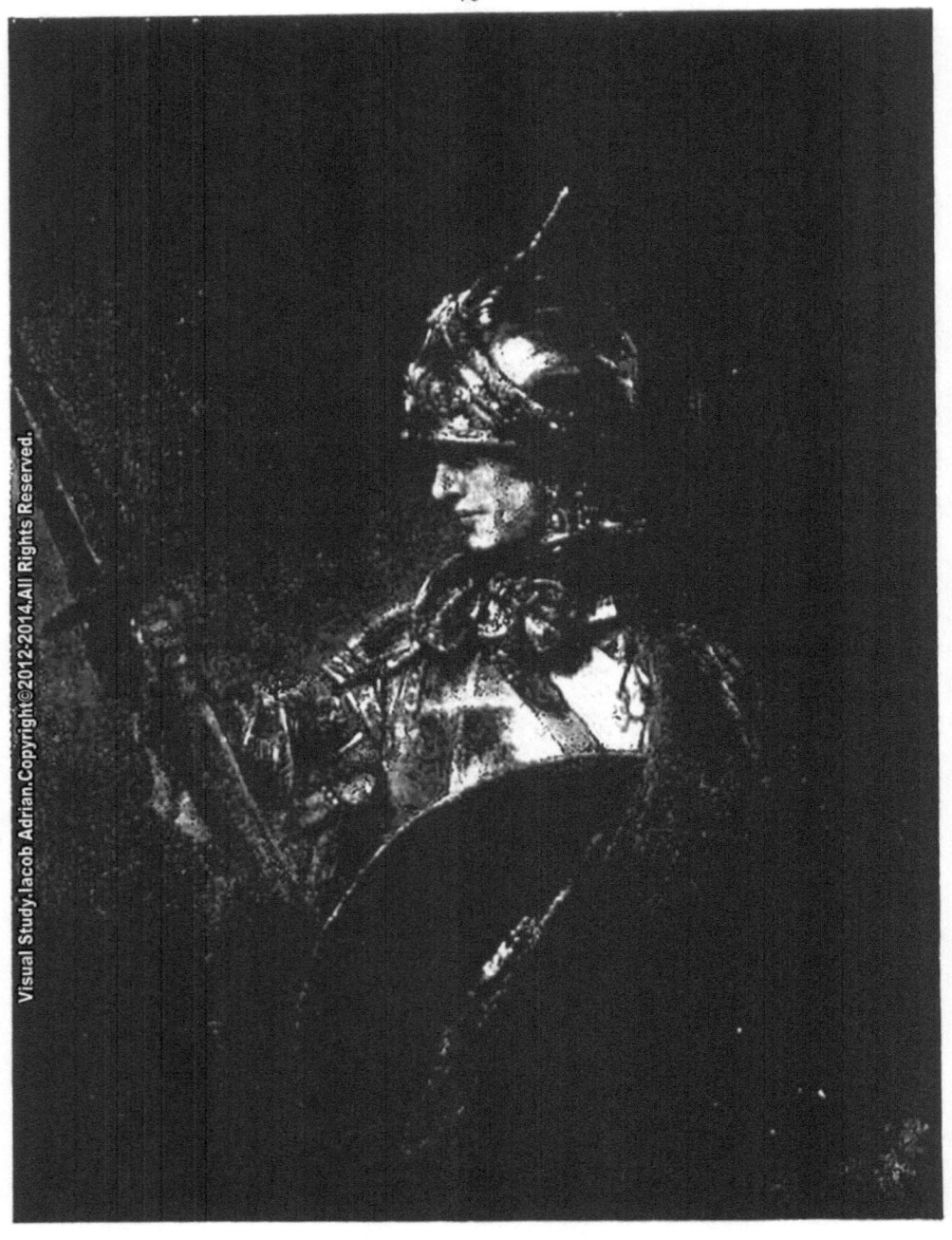

A MAN IN ARMOUR UN HOMME EN ARMURE
(Corporation Gallery, Glasgow) (Galerie municipale, Glasgow)
EIN MANN IN RÜSTUNG
(Glasgow, Städt. Galerie)
F. Hanfstaengl, Photo.

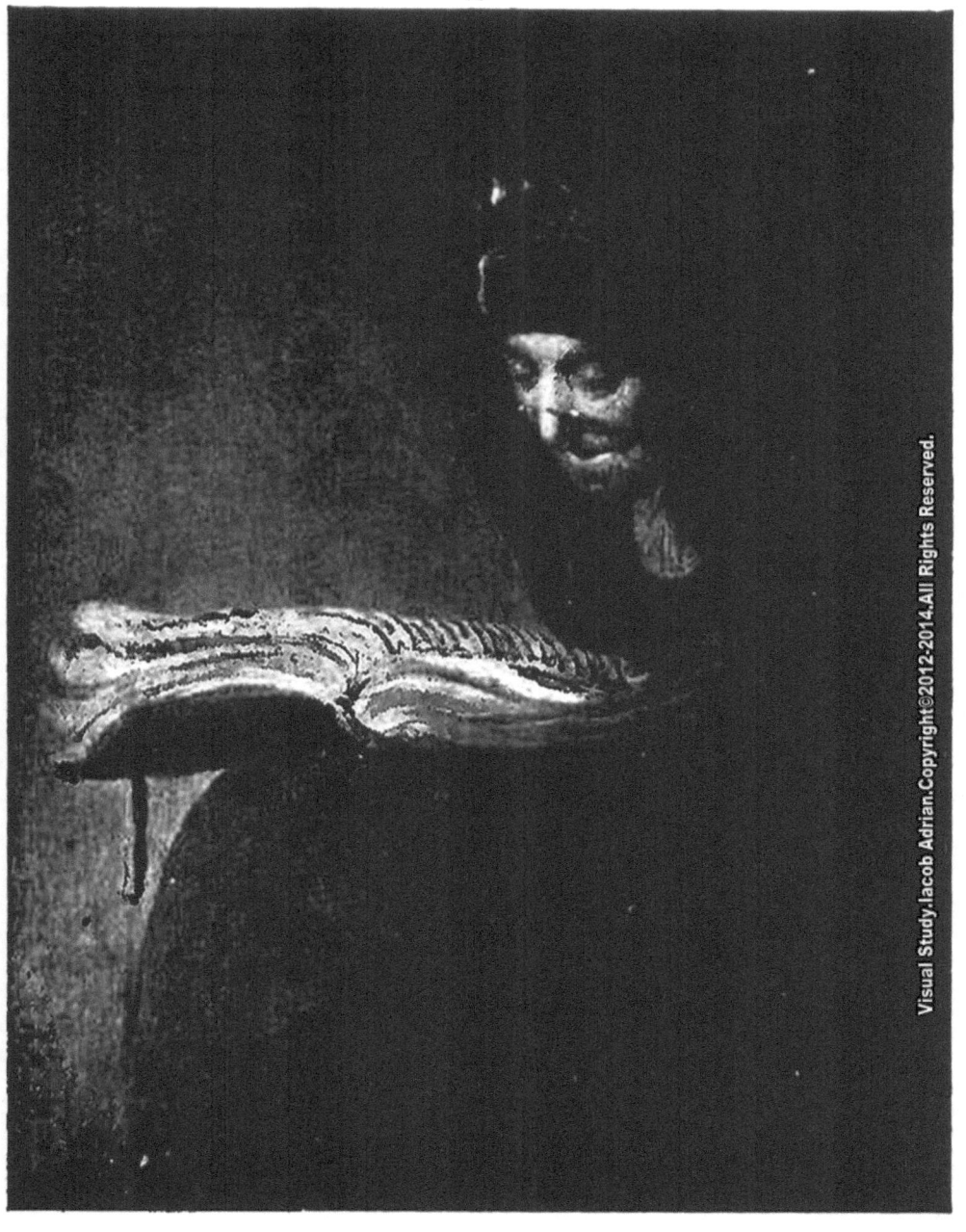

OLD WOMAN READING VIEILLE FEMME LISANT
(Earl of Pembroke's Collection) (Collection du Comte de Pembroke)
LESENDE ALTE FRAU
(Sammlungvom Graf von Pembroke)
F. Hanfstaengl, Photo.

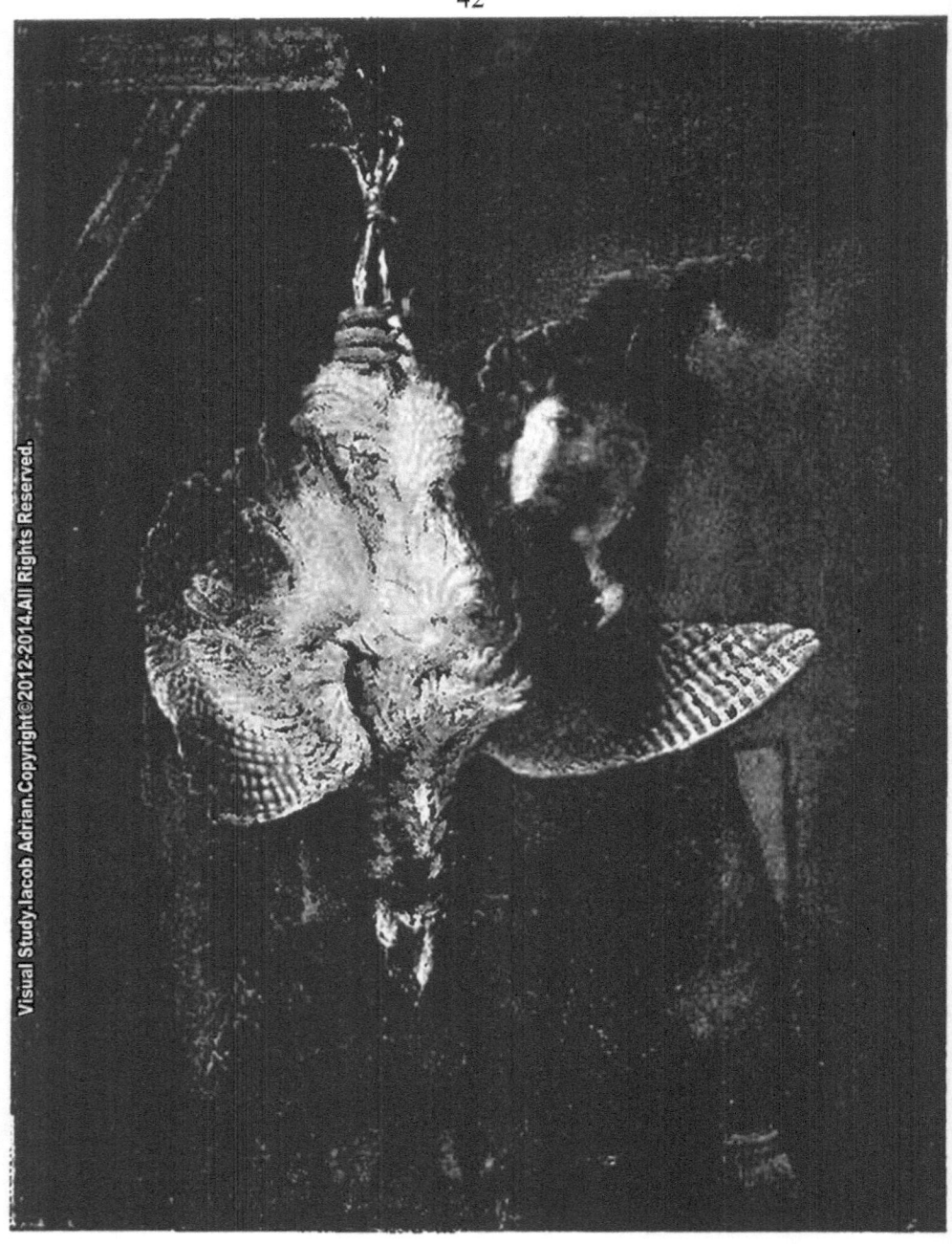

THE BITTERN HUNTER
(*Royal Gallery, Dresden*)

LE CHASSEUR DE BUTOR
(*Galerie royale, Dresde*)

DER ROHRDOMMELJÄGER
(*Dresden, Kgl. Galerie*)
F. Hanfstaengl, Photo.

THE NIGHT WATCH LA RONDE DE NUIT
(Royal Museum, Amsterdam) (Musée royal, Amsterdam)
DIE NACHTRUNDE
(Amsterdam, Kgl. Museum)
F. Hanfstaengl, Photo.

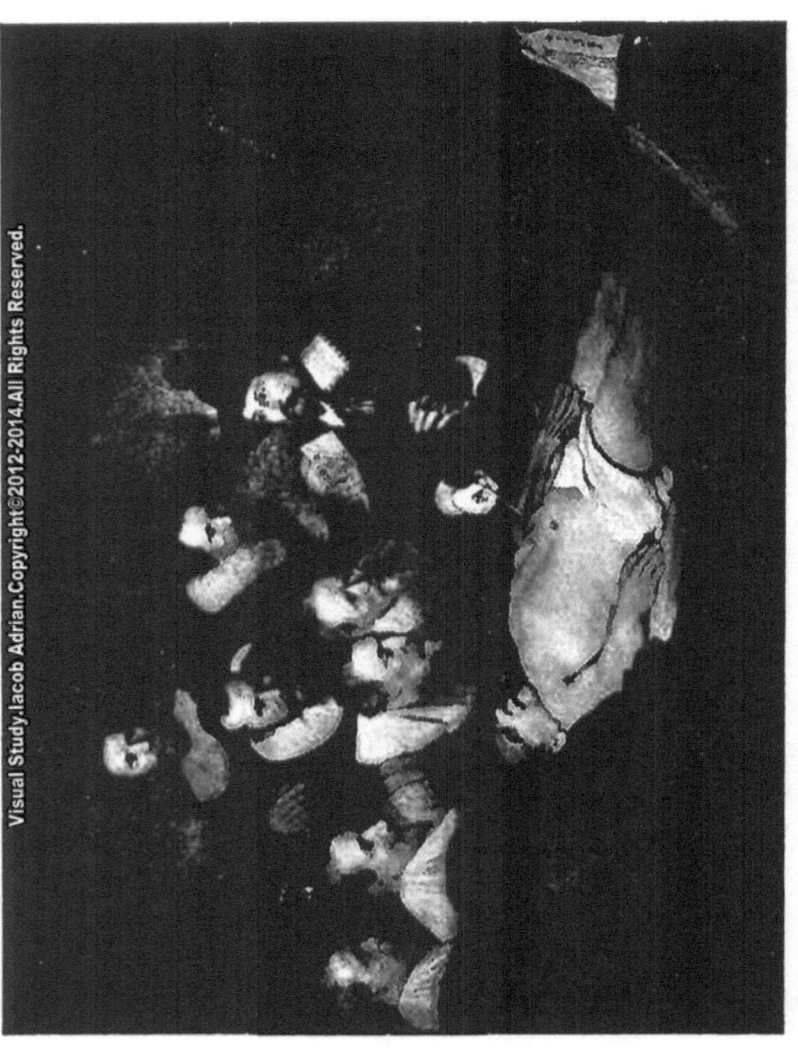

The Anatomy Lesson
(Royal Gallery, The Hague)
Anatomie des Professors Nik. Pietersz Tulp
(Haag, Kgl. Galerie)
La Leçon d'Anatomie
(Musée royal, La Haye)
F. Hanfstaengl, Photo.

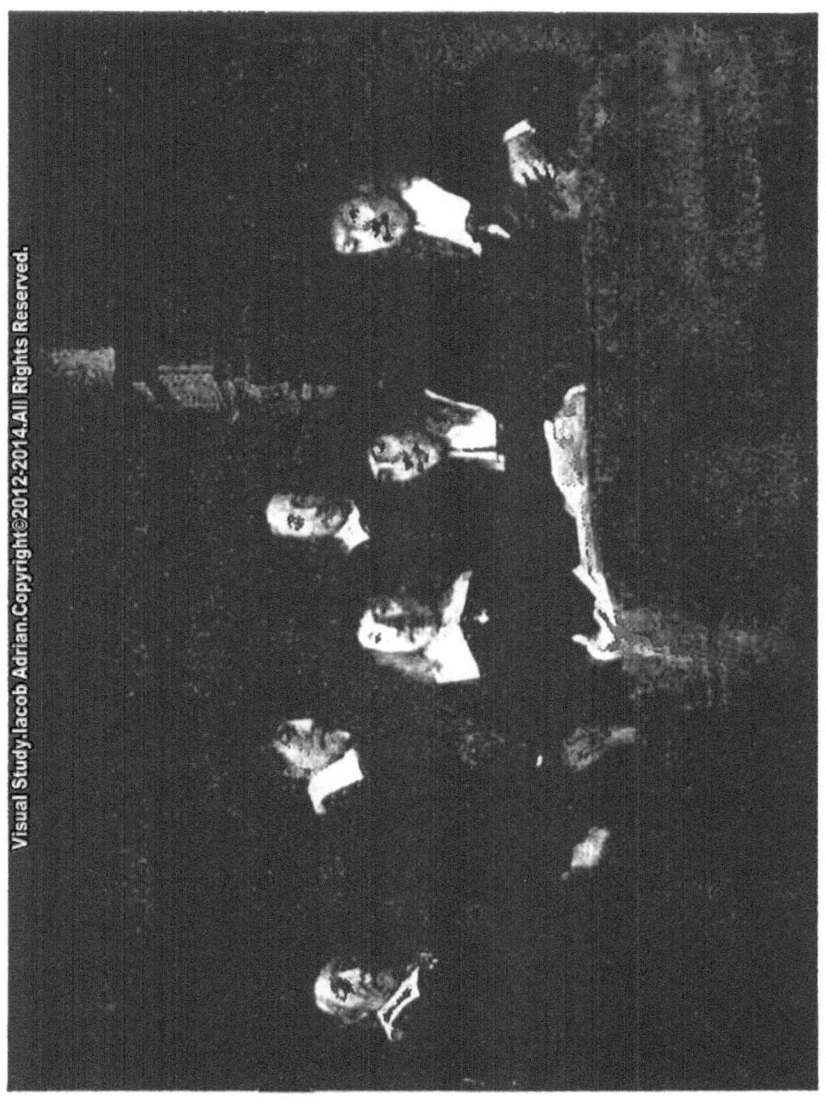

The Syndics of the Cloth Merchants
(Royal Museum, Amsterdam)

Die Syndici der Tuchhändler
(Amsterdam, Kgl. Museum)
F. Hanfstaengl, Photo.

Les Syndics des Drapiers
(Musée royal, Amsterdam)

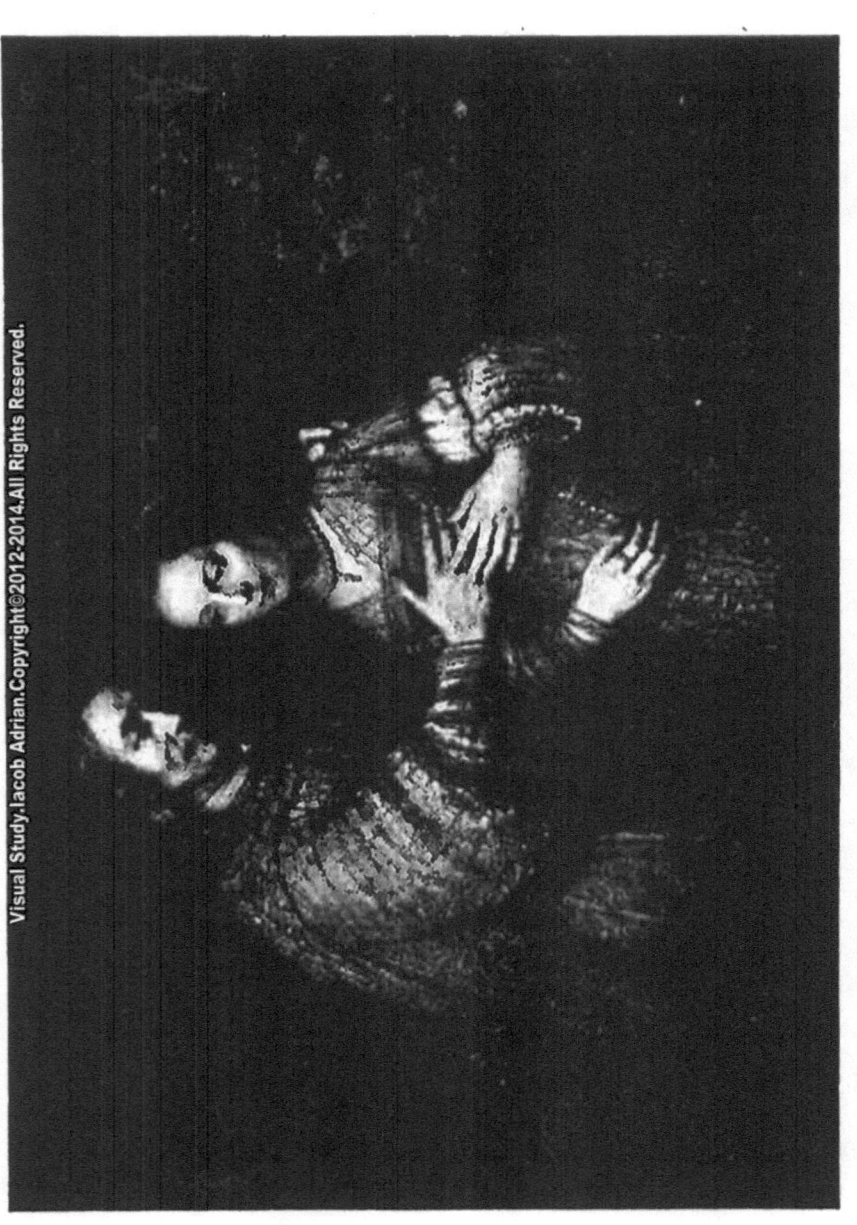

The Jewish Bride Die Judenbraut L'Épouse juive
(Royal Museum, Amsterdam) (Amsterdam, Kgl. Museum) (Musée royal, Amsterdam)
F. Hanfstaengl, Photo.

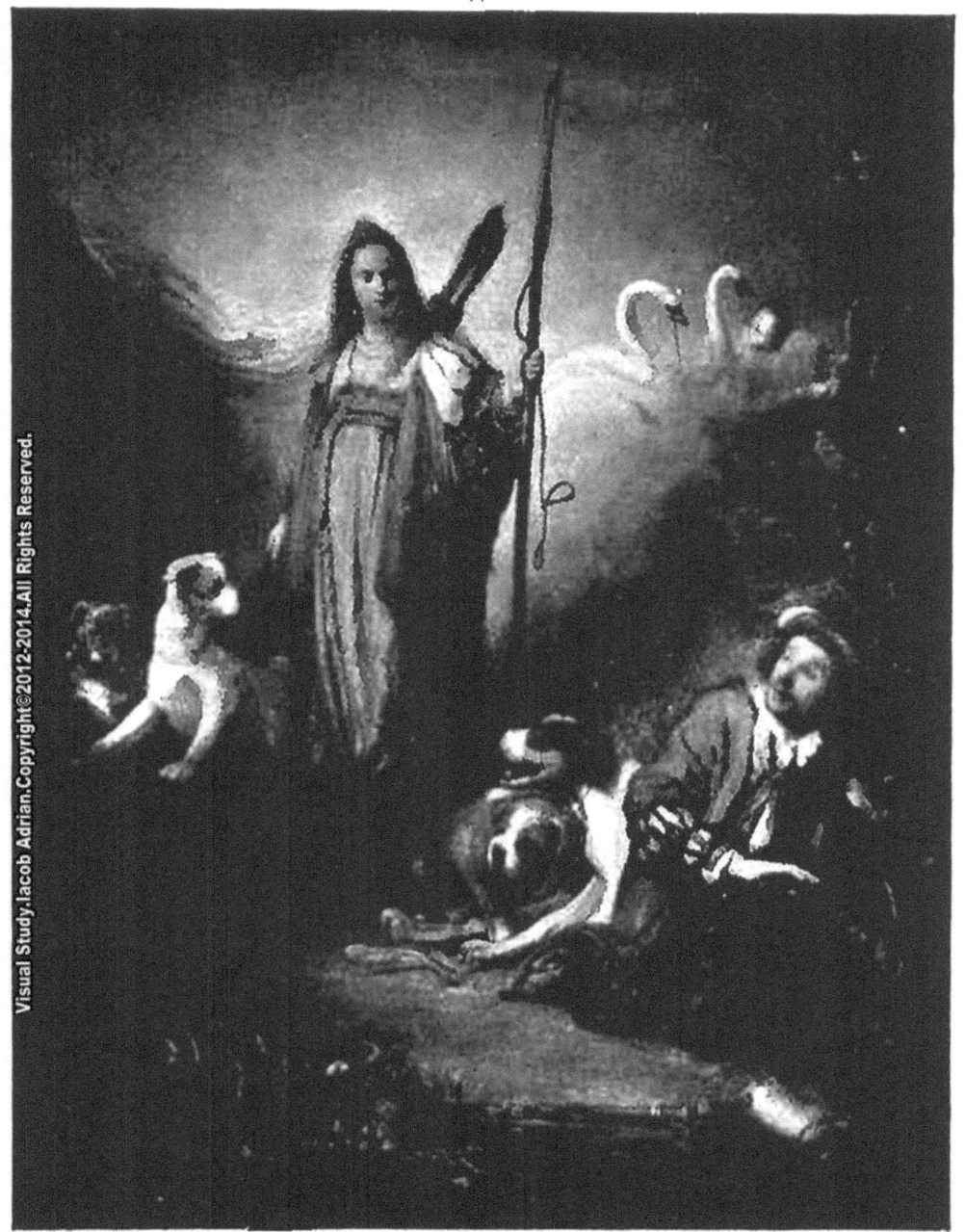

DIANA AND ENDYMION
(Liechtenstein Gallery, Vienna)
DIANE ET ENDYMION
(Galerie Liechtenstein, Vienne)
DIANA UND ENDYMION
(Wien, Galerie Liechtenstein)
F. Hanfstaengl, Photo.

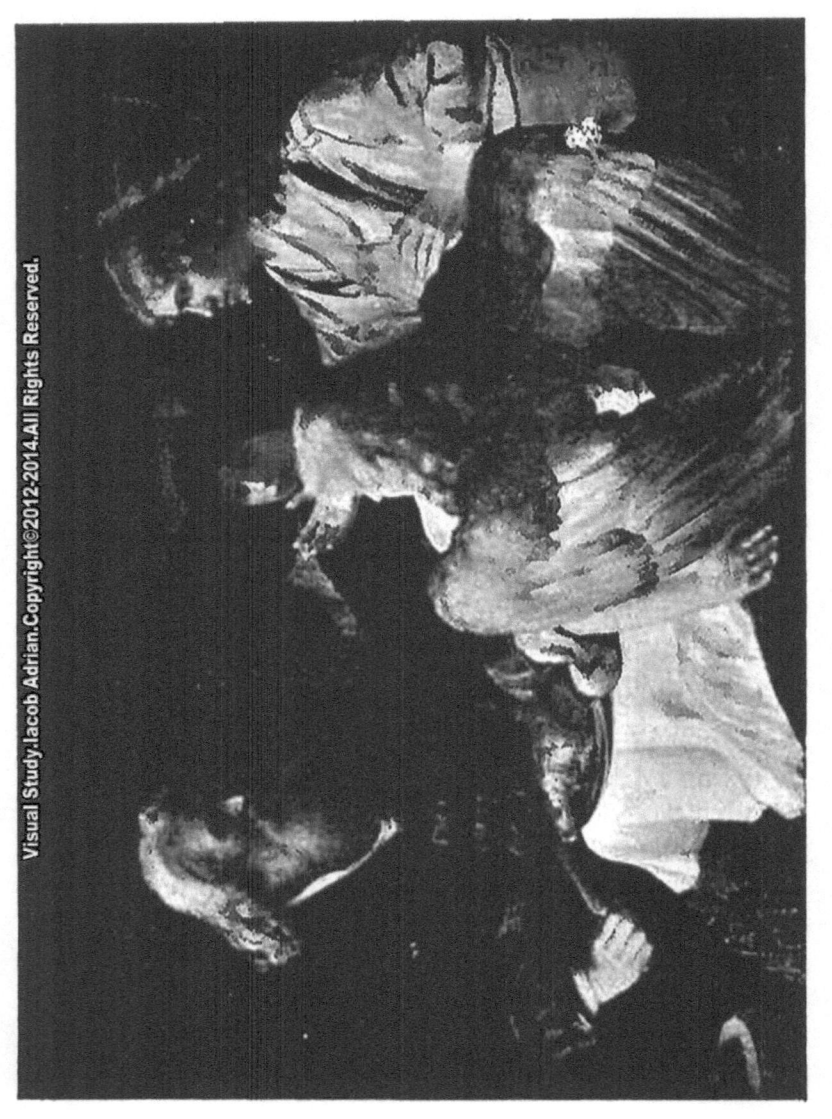

ABRAHAM AND THE THREE ANGELS ABRAHAM ET LES TROIS ANGES
(*The Hermitage, St. Petersburg*) (*L'Ermitage, Saint-Pétersbourg*)
ABRAHAM MIT DEN DREI ENGELN
(*Petersburg, Eremitage*)
F. Hanfstaengl, Photo.

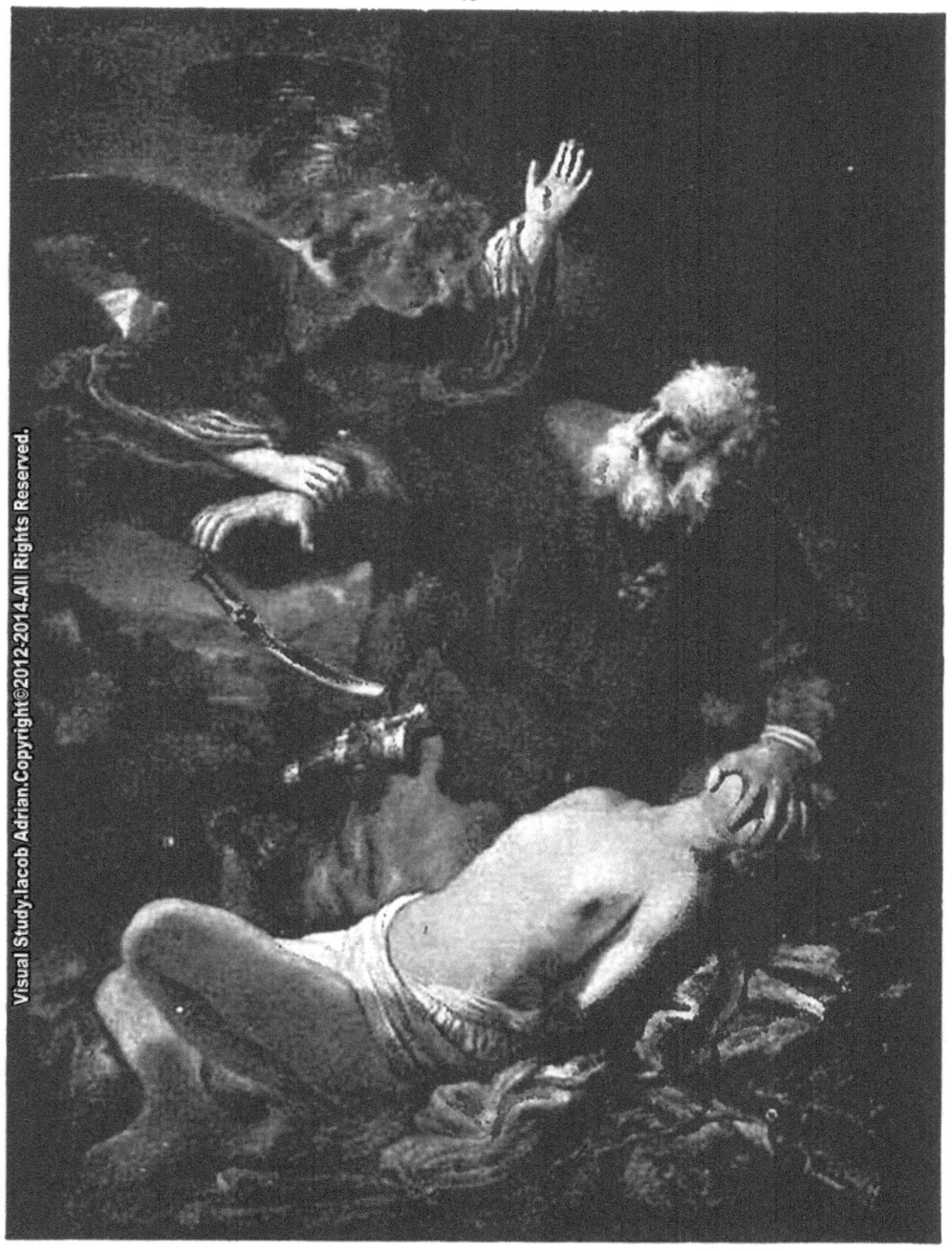

ABRAHAM'S SACRIFICE LE SACRIFICE D'ABRA
(*The Hermitage, St. Petersburg*) (*L'Ermitage, Saint-Péter.*
ABRAHAMS OPFER
(*Petersburg, Eremitage*)
F. Hanfstaengl, Photo.

The Wedding of Samson
(Royal Gallery, Dresden)

Samsons Hochzeit
(Dresden, Kgl. Galerie)
F. Hanfstaengl, Photo.

Noces de Samson
(Galerie royale, Dresde)

THE VISION OF DANIEL
(Royal Gallery, Berlin)

DIE VISION DANIELS
(Berlin, Kgl. Galerie)

LA VISION DE DANIEL
(Musée royal, Berlin)

F. Hanfstaengl, Photo.

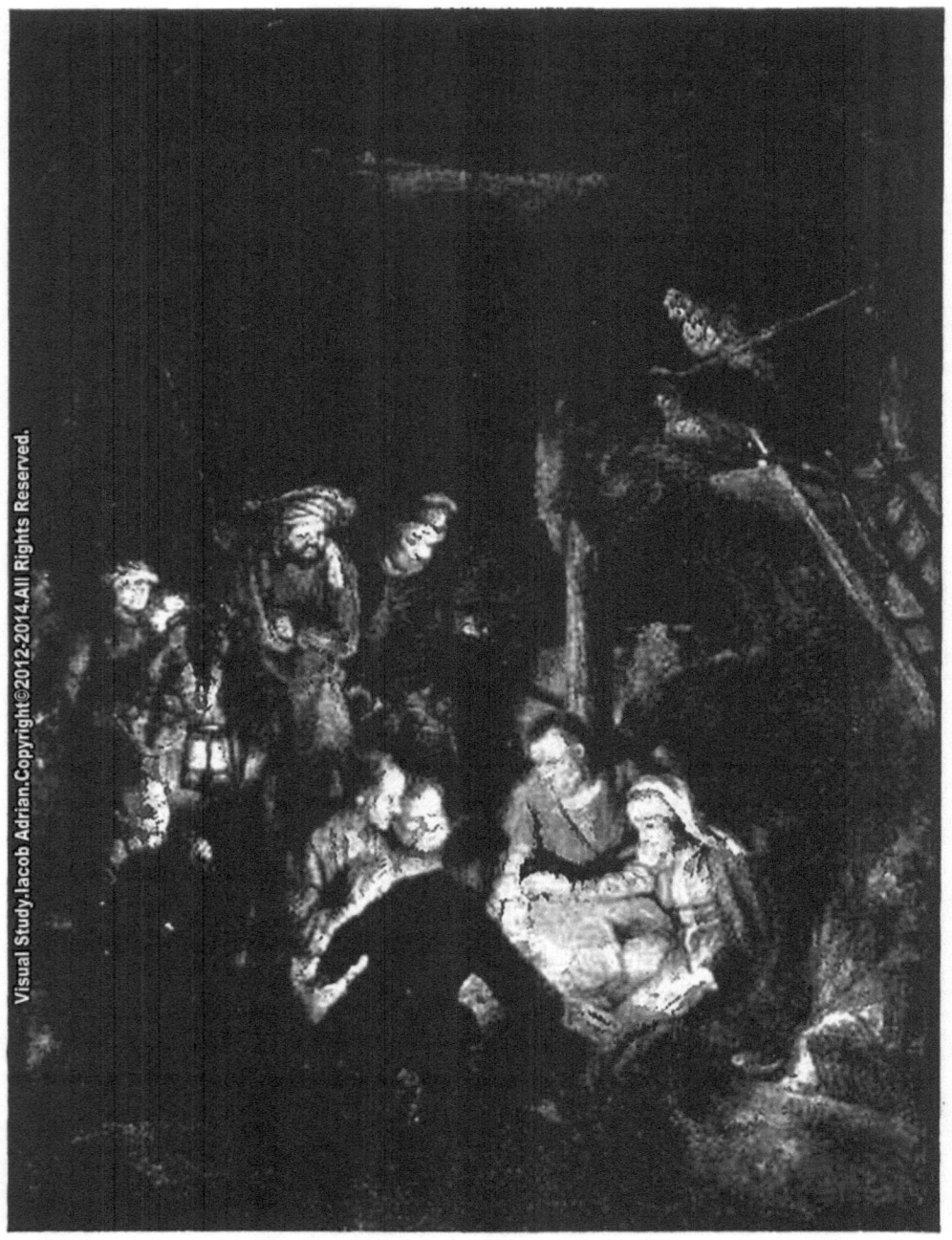

THE ADORATION OF THE SHEPHERDS L'ADORATION DES BERGERS
(Pinakothek, Munich) *(Pinacothèque, Munich)*
DIE ANBETUNG DER HIRTEN
(München, Pinakothek)
F. Hanfstaengl, Photo.

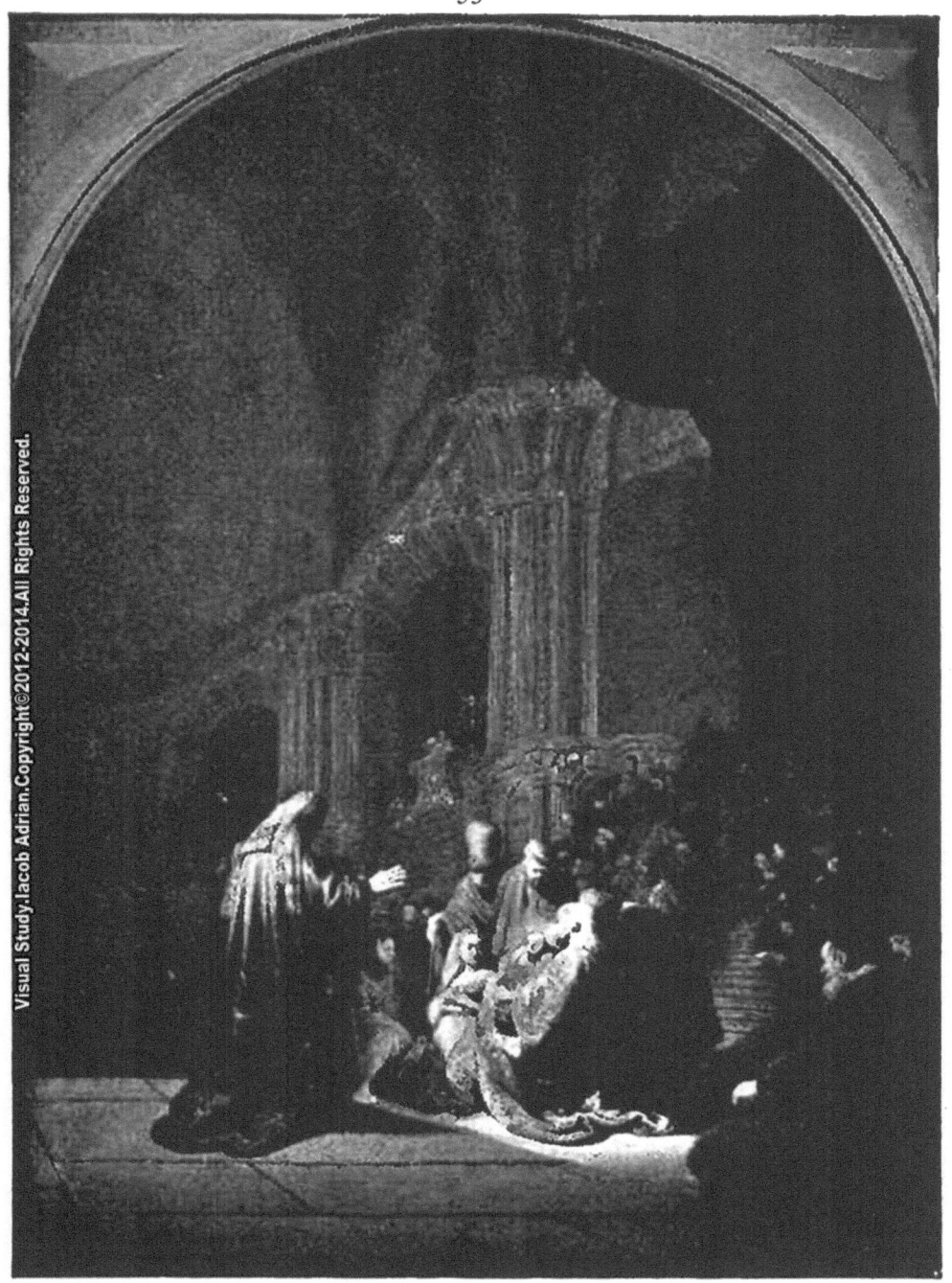

SIMEON IN THE TEMPLE
(*Royal Gallery, The Hague*)

SIMÉON AU TEMPLE
(*Musée royal, La Haye*)

SIMEON IM TEMPEL
(*Haag, Kgl. Galerie*)
F. Hanfstaengl, Photo.

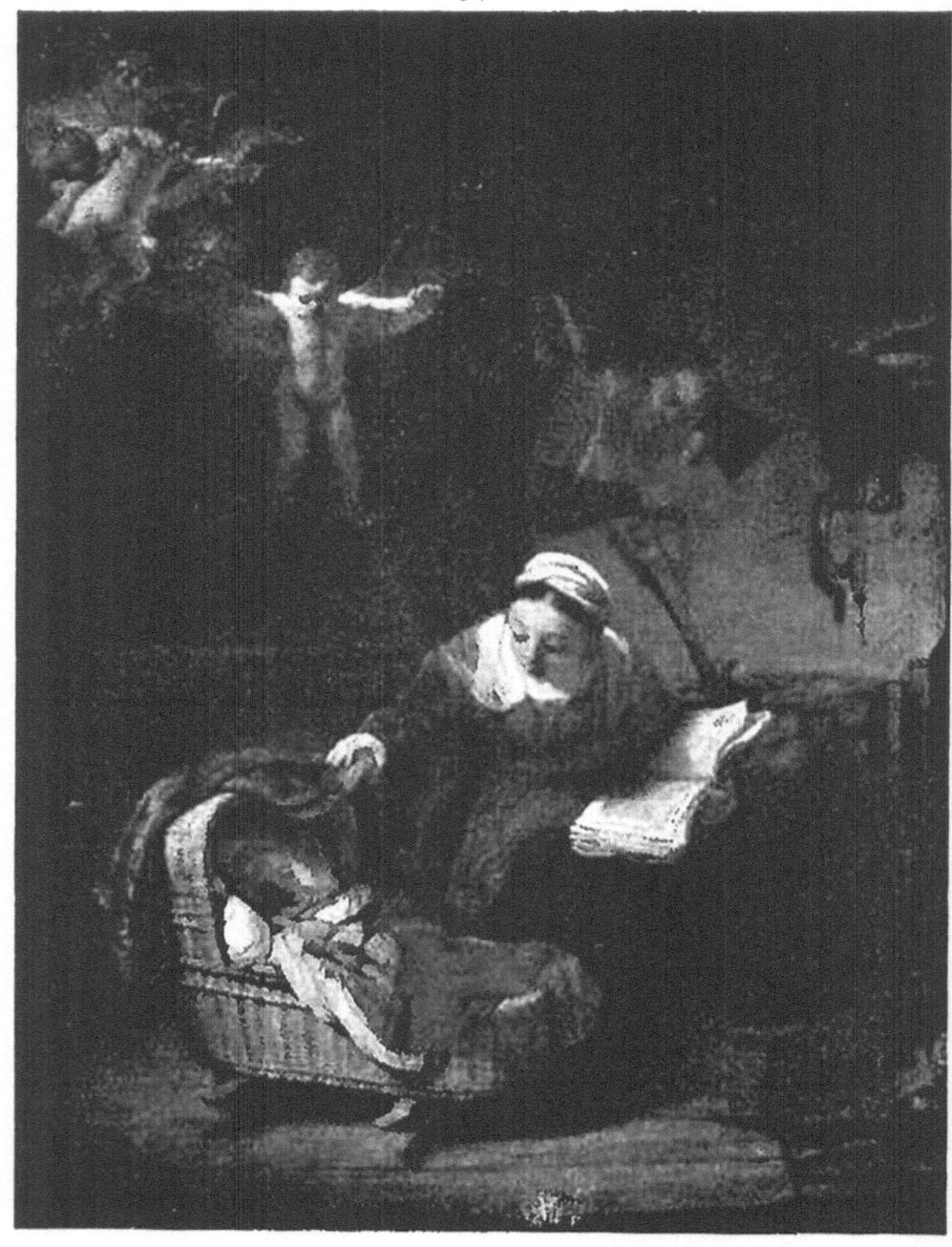

THE HOLY FAMILY SAINTE FAMILLE
(*The Hermitage, St. Petersburg*) (*L'Ermitage, Saint-Pétersbourg*)
DIE HEILIGE FAMILIE
(*Petersburg, Eremitage*)
F. Hanfstaengl, Photo.

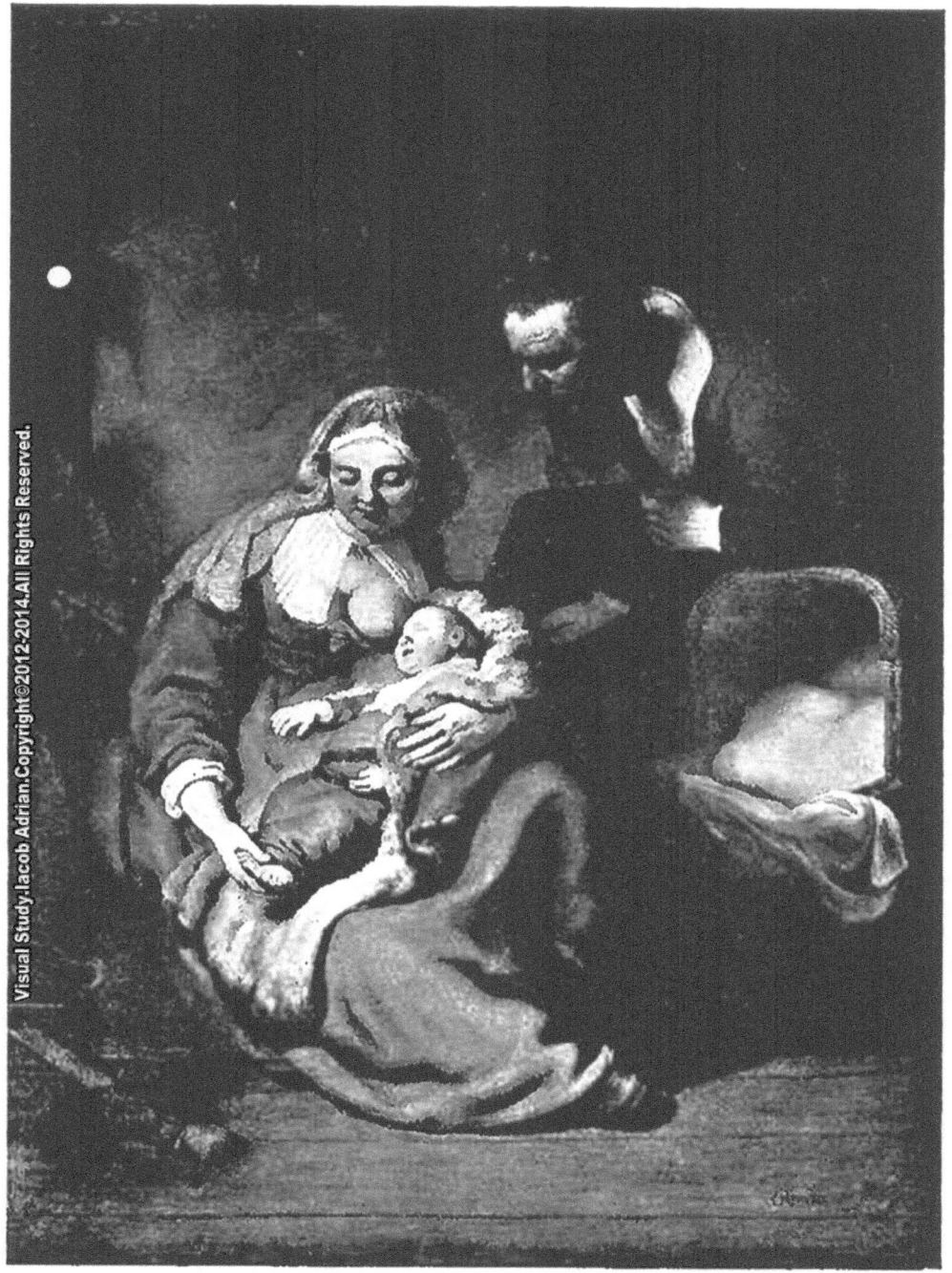

THE HOLY FAMILY
(*Pinakothek, Munich*)

SAINTE FAMILLE
(*Pinacothèque, Munich*)

DIE HEILIGE FAMILIE
(*München, Pinakothek*)
F. Hanfstaengl, Photo.

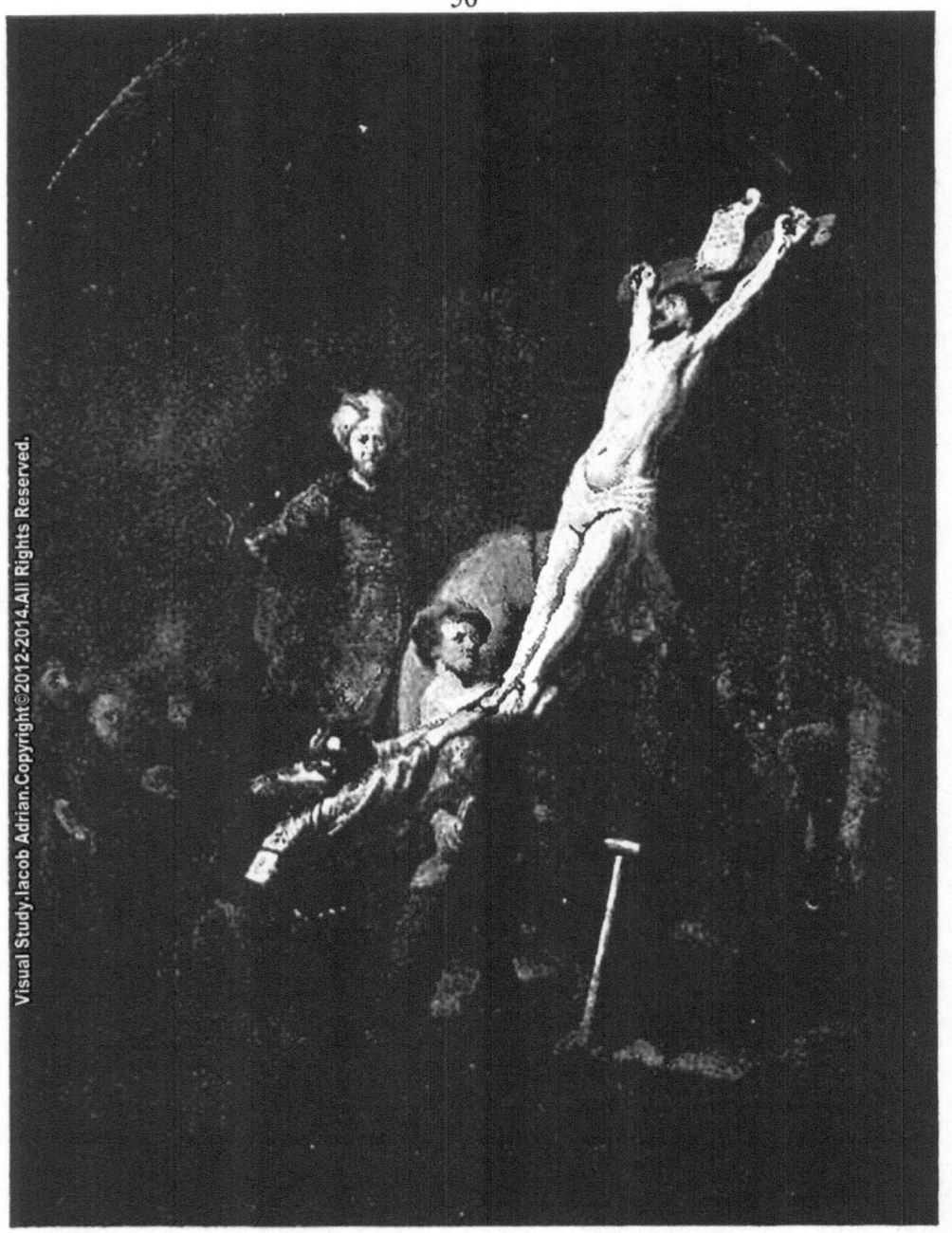

THE RAISING OF THE CROSS
(*Pinakothek, Munich*)

JÉSUS ÉLEVÉ EN CROIX
(*Pinacothèque, Munich*)

DIE KREUZERHÖHUNG
(*München, Pinakothek*)
F. Hanfstaengl, Photo.

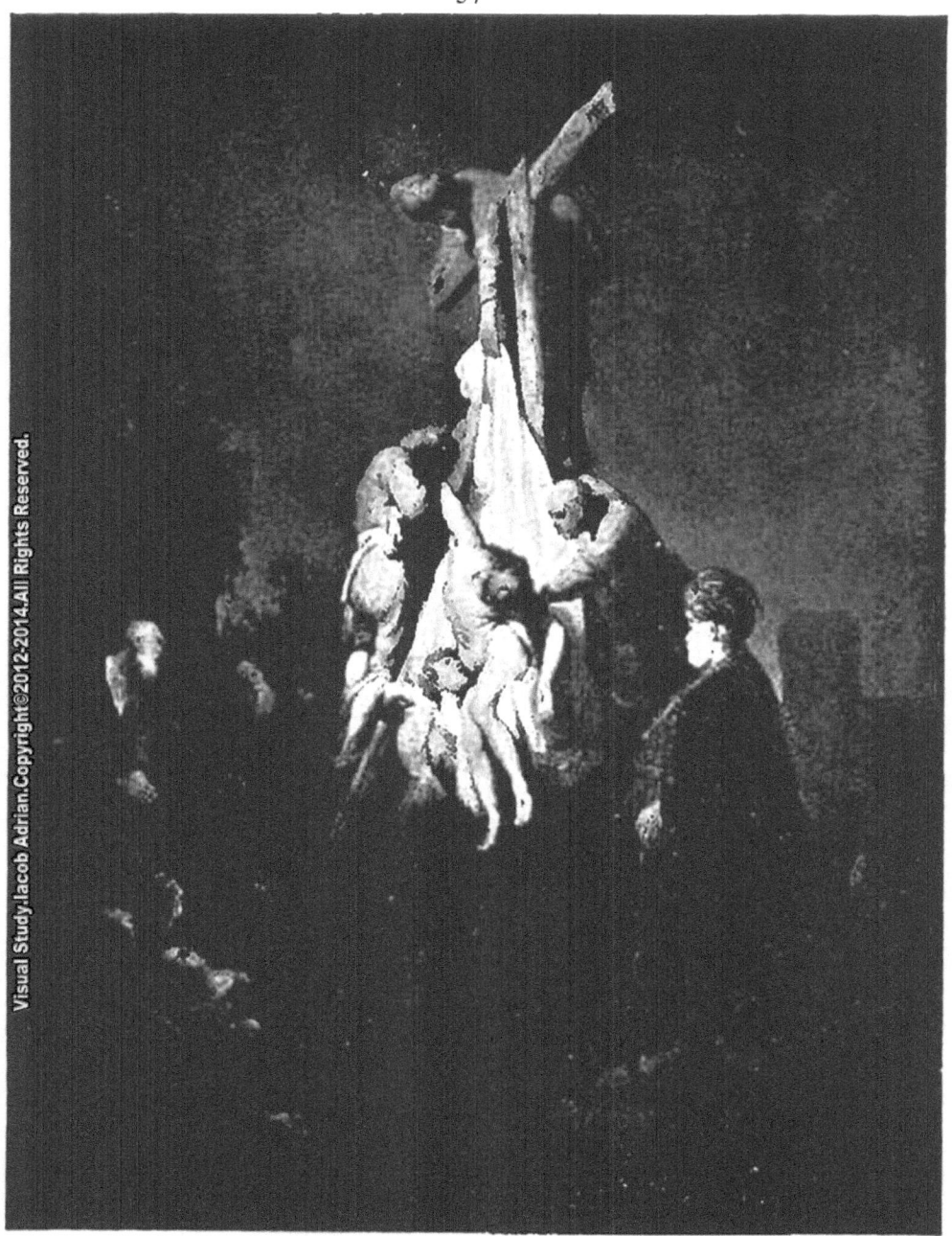

THE DESCENT FROM THE CROSS
(*Pinakothek, Munich*)

DESCENTE DE CROIX
(*Pinacothèque, Munich*)

DIE KREUZABNAHME
(*München, Pinakothek*)
F. Hanfstaengl, Photo.

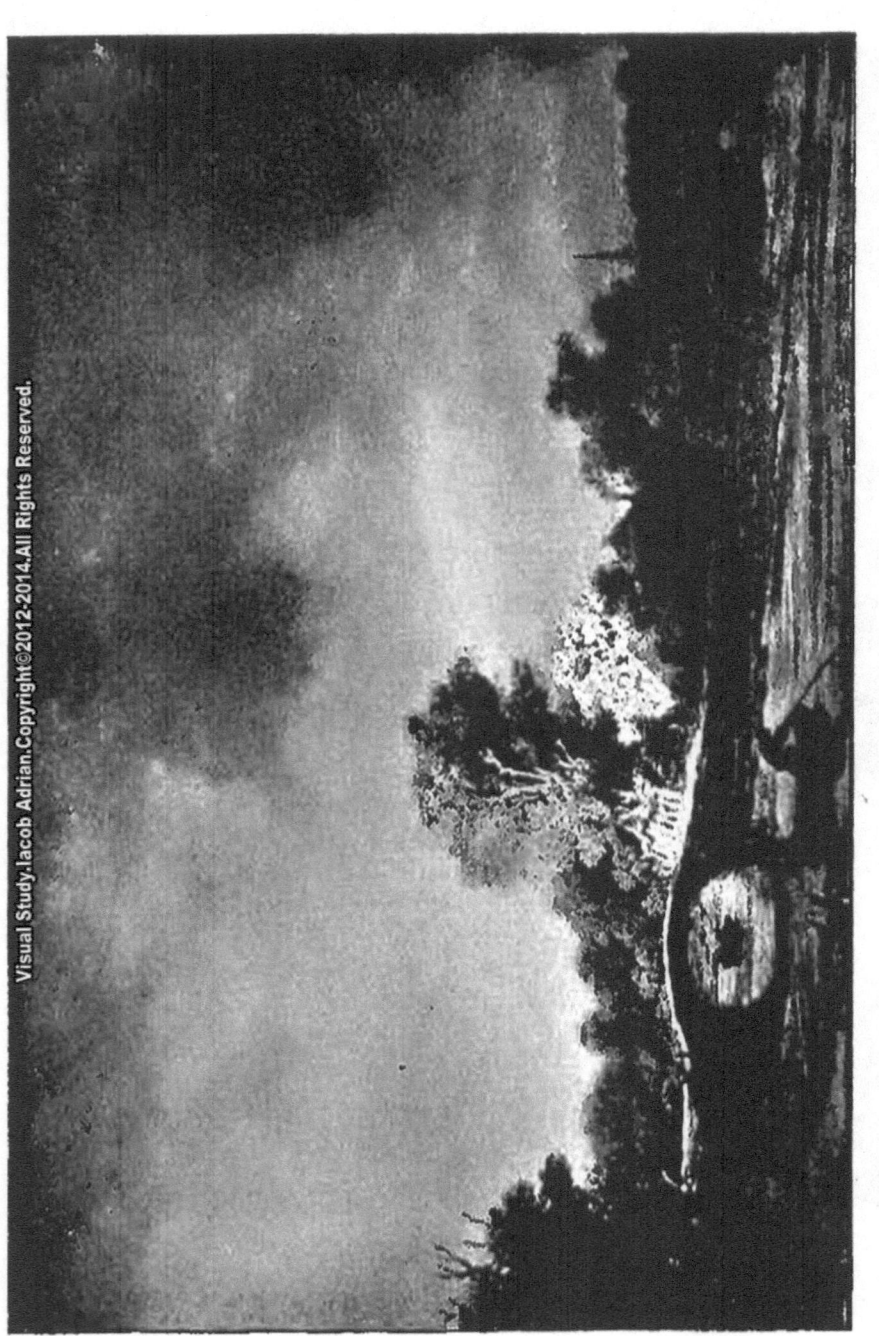

LANDSCAPE
(*Royal Museum, Amsterdam*)

LANDSCHAFT
(*Amsterdam, Kgl. Museum*)
F. Hanfstaengl, Photo.

PAYSAGE
(*Musée royal, Amsterdam*)

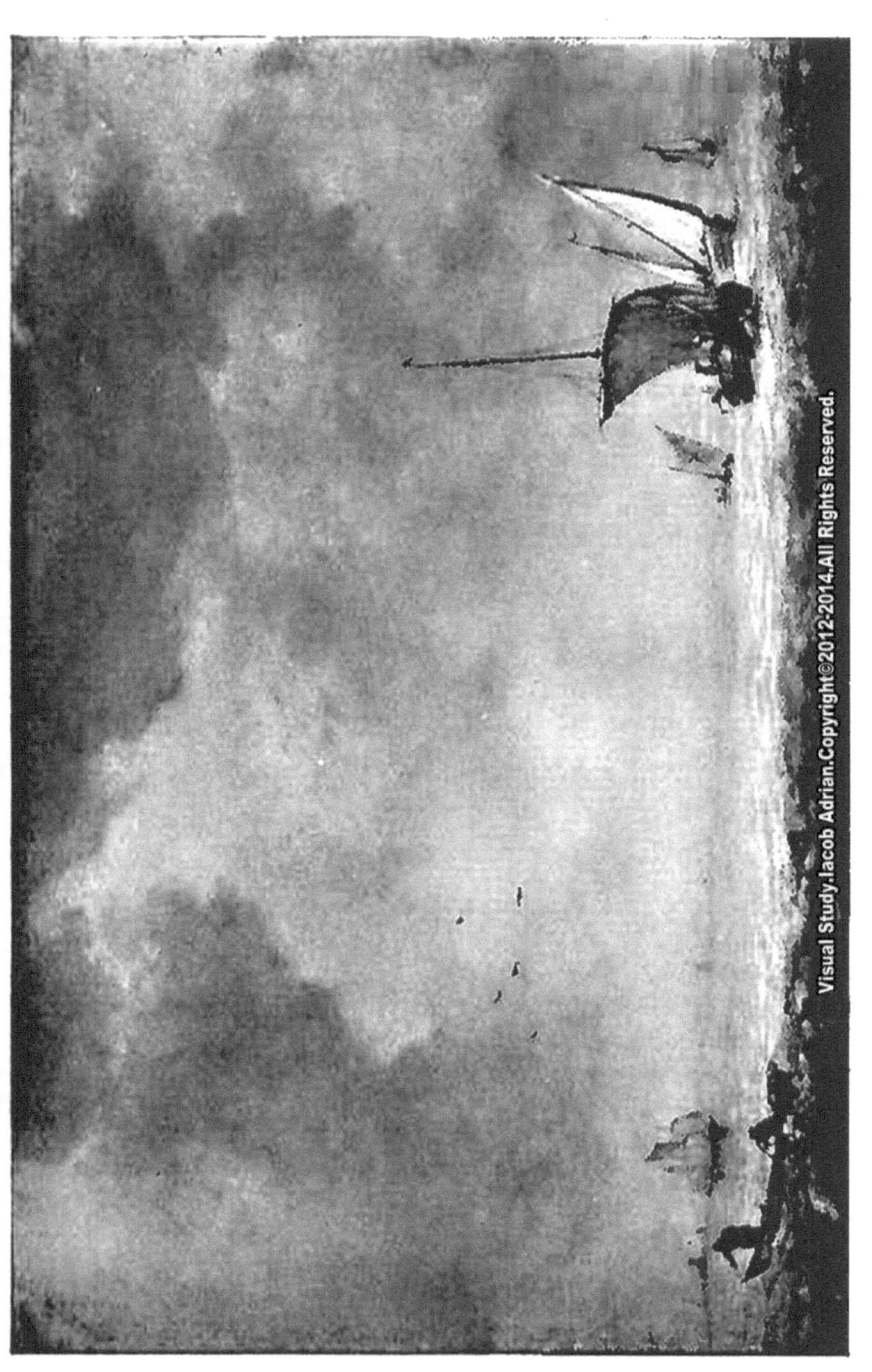

A CALM SEA STILLE SEE MER TRANQUILLE
(Liechtenstein Gallery, Vienna) (Wien, Galerie Liechtenstein) (Galerie Liechtenstein, Vienne)
F. Hanfstaengl, Photo.

Bibliographic sources :

The masterpieces of Rembrandt; (1907)

Author:
Rembrandt Harmenszoon van Rijn, 1606-1669

Publisher: London, Gowans

This documentary study use,
combined in various proportions,
elements from the following categories,
forms and subsets :
- fair use
- documentary
- documentary photography
- feature
- journalism
- arts journalism
- visual journalism
- photojournalism
- celebrity photography
in order to :
- employ material as the object of cultural critique ,
- quote to illustrate an argument or point ,
- use material in historical sequence,
providing independent opinion,
using photos, press articles, advertisements,
opinions of fans etc. ...

Copyright©2012-2014 Iacob Adrian
All Rights Reserved.

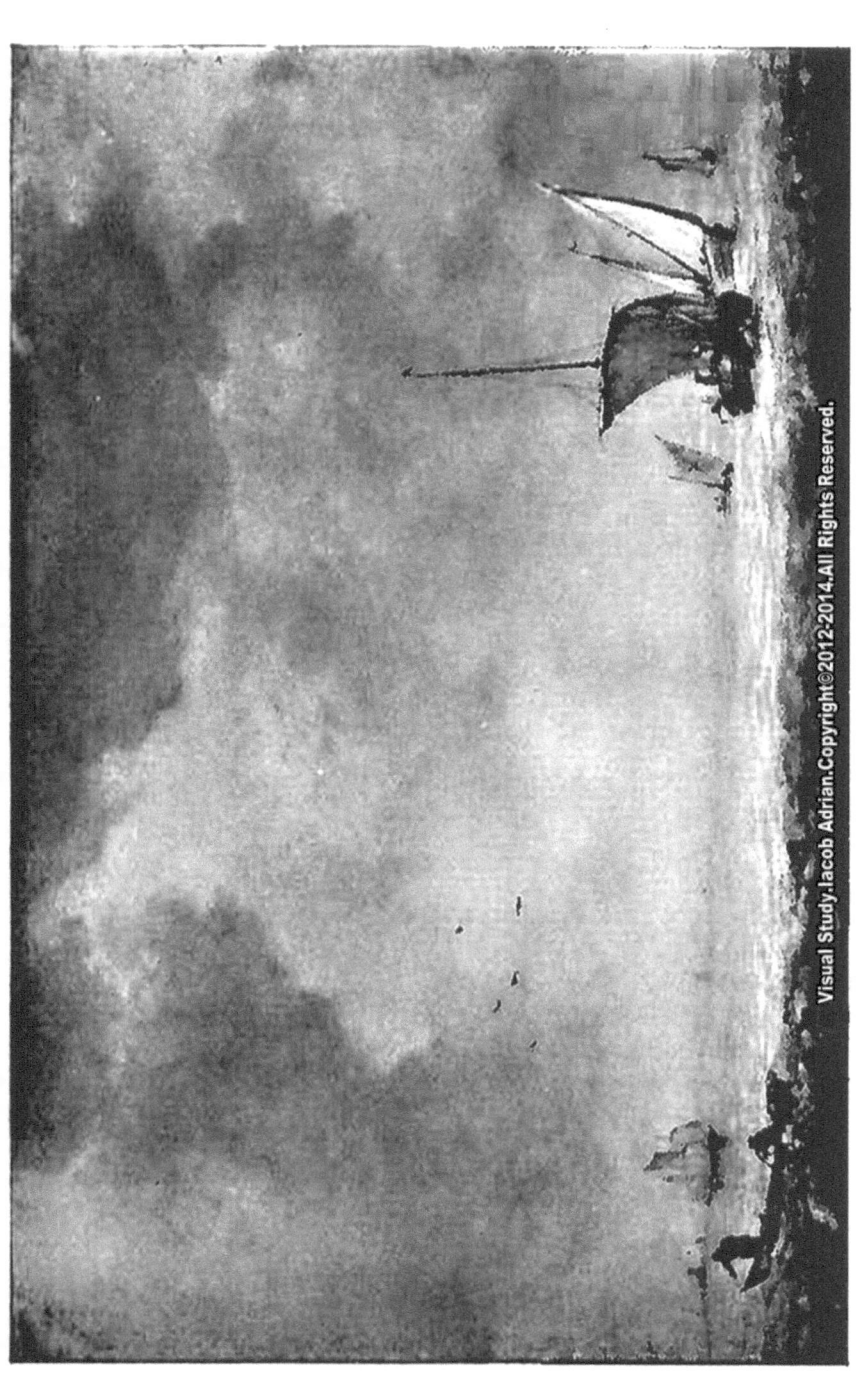

A CALM SEA STILLE SEE MER TRANQUILLE
(Liechtenstein Gallery, Vienna) (Wien, Galerie Liechtenstein) (Galerie Liechtenstein, Vienne)
F. Hanfstaengl, Photo.

Bibliographic sources :

The masterpieces of Rembrandt; (1907)

Author:
Rembrandt Harmenszoon van Rijn, 1606-1669

Publisher: London, Gowans

This documentary study use,
combined in various proportions,
elements from the following categories,
forms and subsets :
- fair use
- documentary
- documentary photography
- feature
- journalism
- arts journalism
- visual journalism
- photojournalism
- celebrity photography
in order to :
- employ material as the object of cultural critique ,
- quote to illustrate an argument or point ,
- use material in historical sequence,
providing independent opinion,
using photos, press articles, advertisements,
opinions of fans etc. ...

Copyright©2012-2014 Iacob Adrian
All Rights Reserved.

www.ingramcontent.com/pod-product-compliance
Lightning Source LLC
Chambersburg PA
CBHW021022180526
45163CB00005B/2071